THE SHAPE OF THINGS TO COME: NEW SCULPTURE

SAATCHI G RK'S HQ LONDON

THE SHAPE OF THINGS TO COME

Introduction and texts by Lupe Núñez-Fernández

Golems, effigies, altars, reliquaries and ruins ominously surface among the sculptural works in this exhibition and catalogue, but the shape of things to come is not to be found in straightforward, nostalgic re-workings of historical artefacts and systems of knowledge. The shapes and visual metaphors created from ordinary materials and techniques by these twenty international artists reveal a paradoxical re-engagement with the tradition of sculpture. At once full of historical reverberations but also futuristically utopian – if not post-apocalyptic – these new objects feel like a clearing of the board, a starting over from scratch.

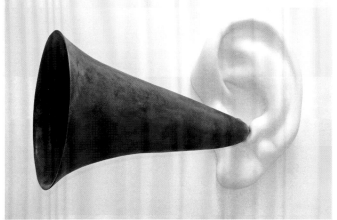

John Baldessari, Beethoven's Trumpet (With Ear) Opus # 133, 2007

Dust, earth, papier mâché, fur, plaster, rock, wood, Styrofoam and other industrial and found materials (as well as immaterial components such as sound and light) are woven into assemblages and figures which occupy a space between abstraction and figuration, as if in a state of metamorphosis. Their raw in-between-ness is articulated in emphatically physical ways, and a feel for the everyday and the real is felt not only through the choices of materials, but also in the deliberately unmonumental compositions of some of these works.

The flimsy, mundane materials, some of which have been scavenged off the streets, emphasize the fragility and mutability of contemporary sculpture, and through their materials these artists seem to be calling into question the permanence of preconceived notions about what sculpture is and might be.

While modernism, the Duchampian readymade and Joseph Beuys-style shamanistic symbolism are references lurking around these works, they are re-contextualised through the lens of contemporary popular culture by artists who are aware of the recent economic instability and the effects of globalisation.

The works in the exhibition reveal the power of the artist to make us believe in make-believe, as well as sculpture's particular capacity to change the way we perceive our relationship to the world and the spaces which we inhabit and occupy. However imbued they are with the aura of the past and a much less certain future, these works root us both spatially and materially in their immediate presence – and in the present moment.

Many of these sculptures point to a pervasive multidisciplinarity in contemporary art in which artists are combining a range of practices from drawing and architectural design to anthropology and pop culture. A new, almost frenzied interest in practically everything is juxtaposed with a strong desire to reconnect with the traditional idea of a sculptor making work with his or her hands.

Part of this re-definition of the potential role and function of sculpture is reflected through an updated preoccupation with the most traditional sculptural subject – the human figure and figuration in general. Large-scale anthropomorphic works by David Altmejd, Folkert de Jong, Martin Honert and John Baldessari are both comforting and terrifying in their uncanny detail and exploration of scale. Animal shapes by Joanna Malinowska and Berlinde De Bruyckere provoke uneasy reactions triggered by the idea of objectification. Anselm Reyle's borrowed and recycled modernist language of figuration opens up debate around appropriation. Installations by Matthew Brannon, David Batchelor and Kris Martin incorporate the familiarity of known shapes to suggest unexpected narratives.

The physical and chemical qualities of ordinary dirt and paper, plaster and clay and urban decay translate the vocabulary of traditional sculpture into new icons for our time: consider the monumentalising ugliness of Sterling Ruby's installations; Thomas Houseago's standing cartoons; Peter Buggenhout's studied 'ruins'; Björn Dahlem's fragile cosmologies made out of found wood and lights; Dirk Skreber's crashed cars; the crystal-based architectural interventions of Roger Hiorns; the DIY design of Oscar Tuazon's *Bed*; Rebecca Warren's unfired clay female shapes; David Thorpe's labour-intensive cut-out designs; and Matthew Monahan's plinth assemblages.

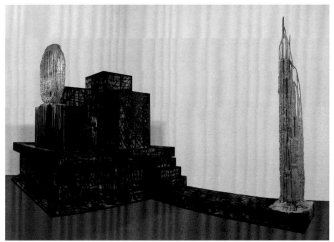

Sterling Ruby, Recondite, 2007

In each of the galleries an object or installation faces or envelops the viewer, reminding us to look again at things taken for granted: at the body, at materials, at scale, or at the scenario, context and idea of the gallery display itself. These sculptures seem to prophesy that from now on the meaning of all these things will be different, that this might indeed be the shape of things to come.

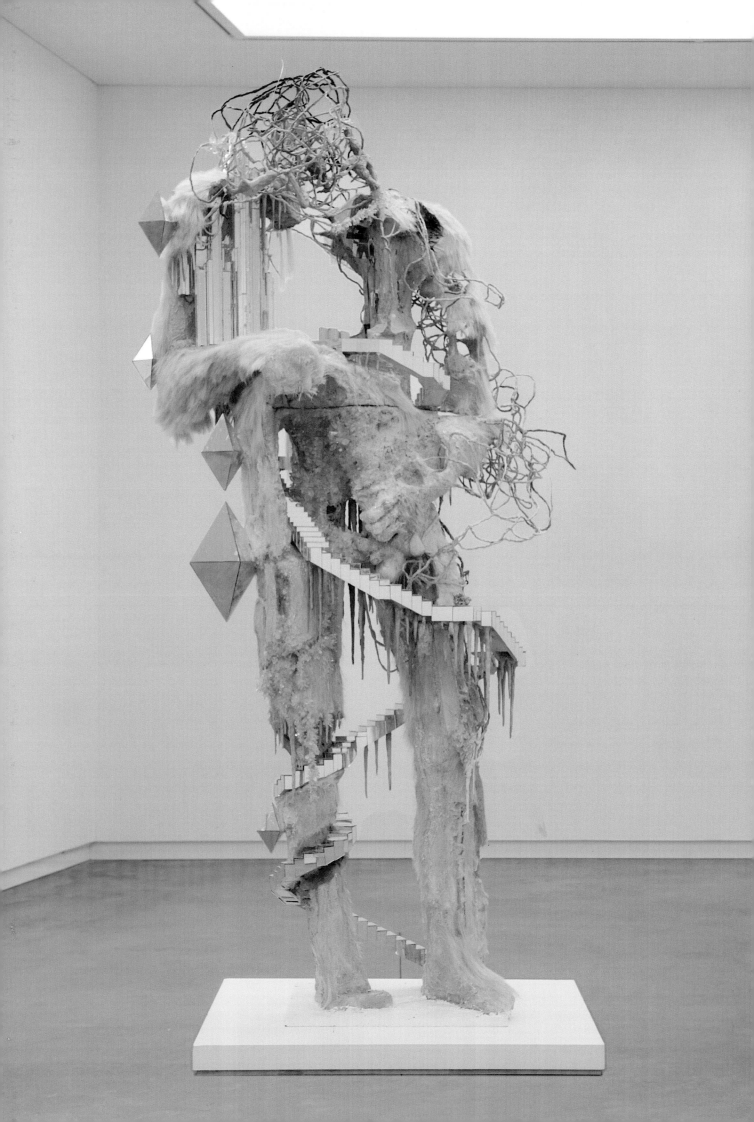

DAVID ALTMEJD
The New North 2007
Wood, foam, expandable foam, resin, paint, magic-sculpt, magic-smooth, epoxy, glue, mirror, horse hair, quartz crystals and wire
368.3 x 134.6 x 106.7 cm

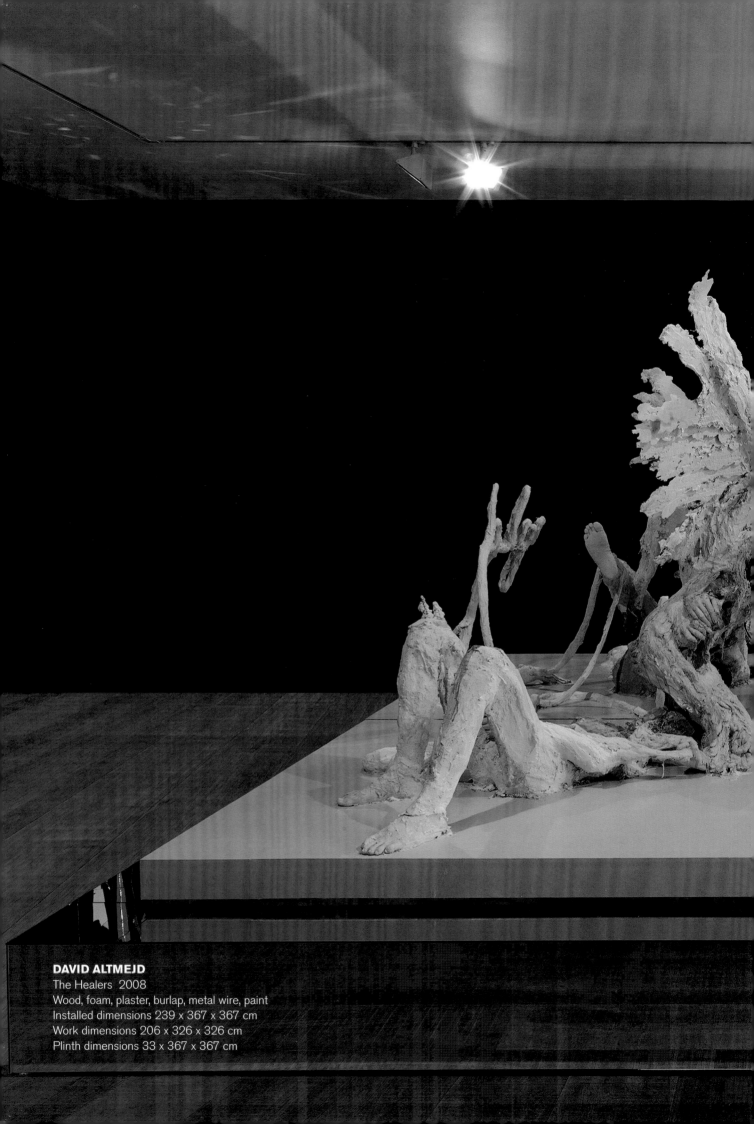

DAVID ALTMEJD
The Healers 2008
Wood, foam, plaster, burlap, metal wire, paint
Installed dimensions 239 x 367 x 367 cm
Work dimensions 206 x 326 x 326 cm
Plinth dimensions 33 x 367 x 367 cm

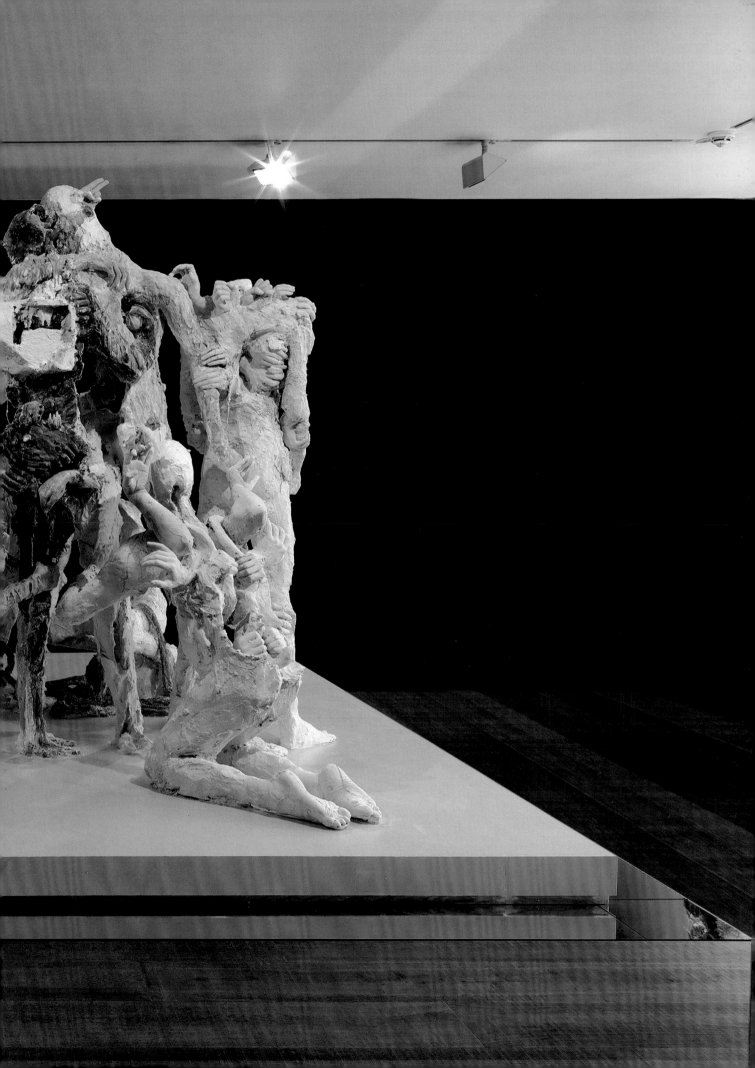

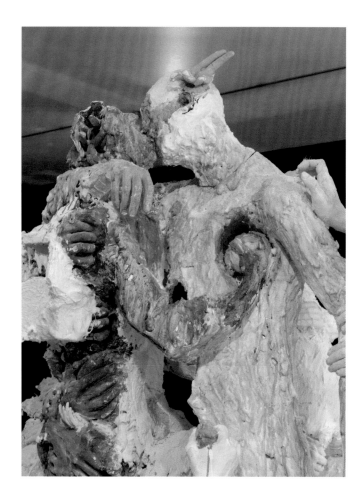

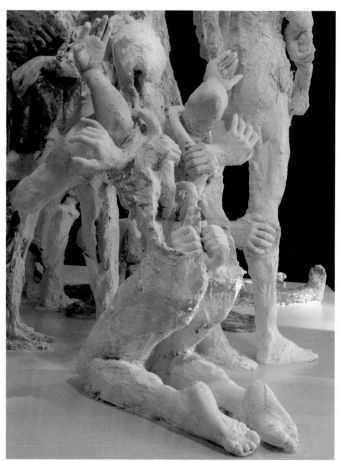

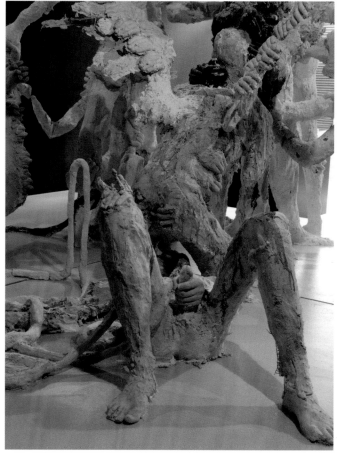

DAVID ALTMEJD
The Healers 2008 (details)

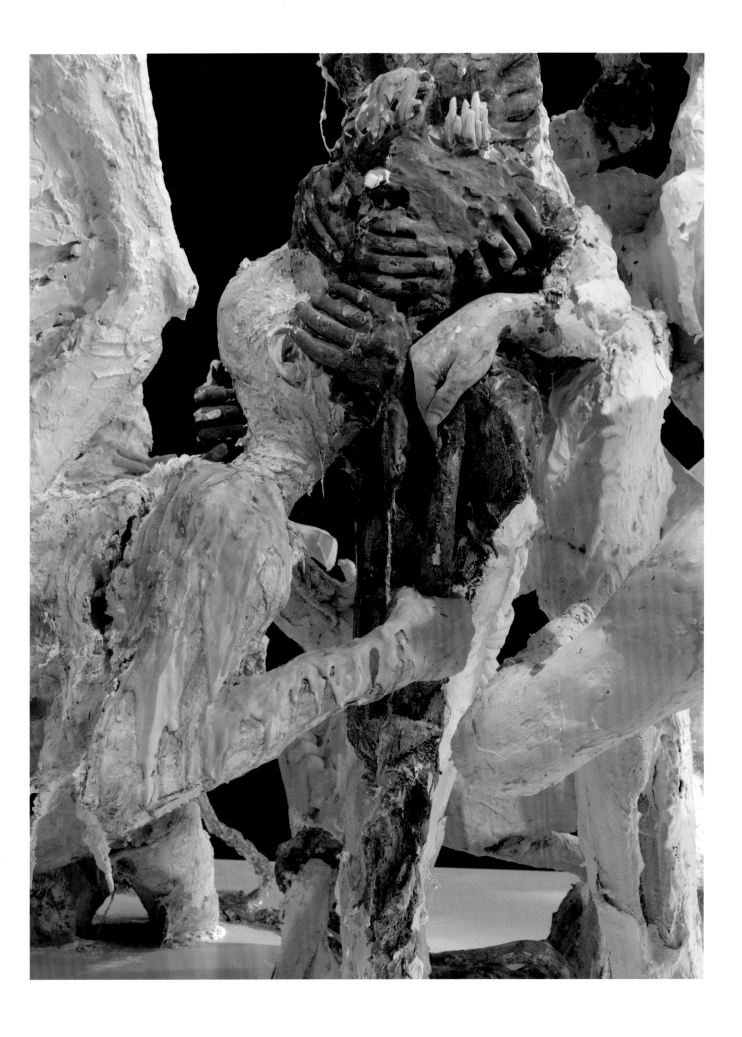

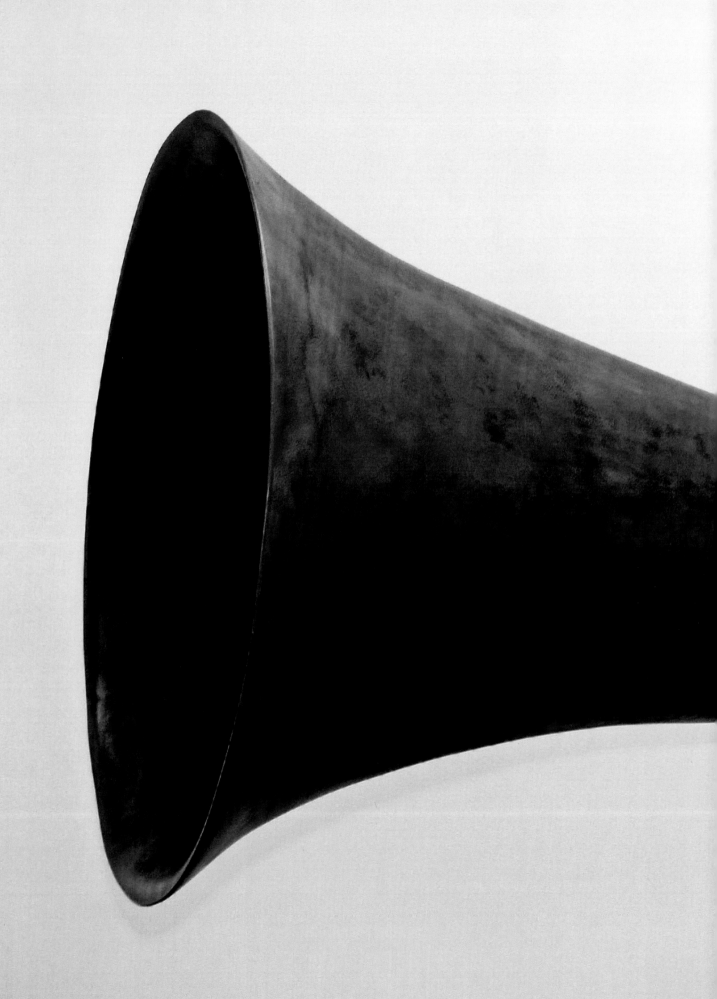

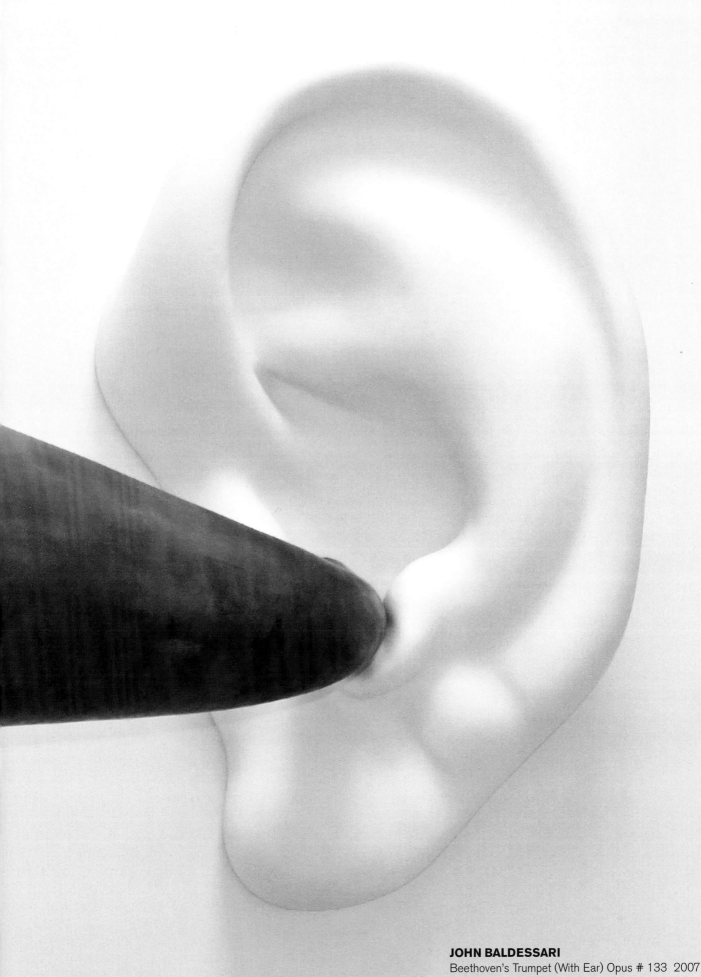

JOHN BALDESSARI
Beethoven's Trumpet (With Ear) Opus # 133 2007
Resin, fibreglass, bronze, aluminium, and electronics
186 x 183 x 267 cm

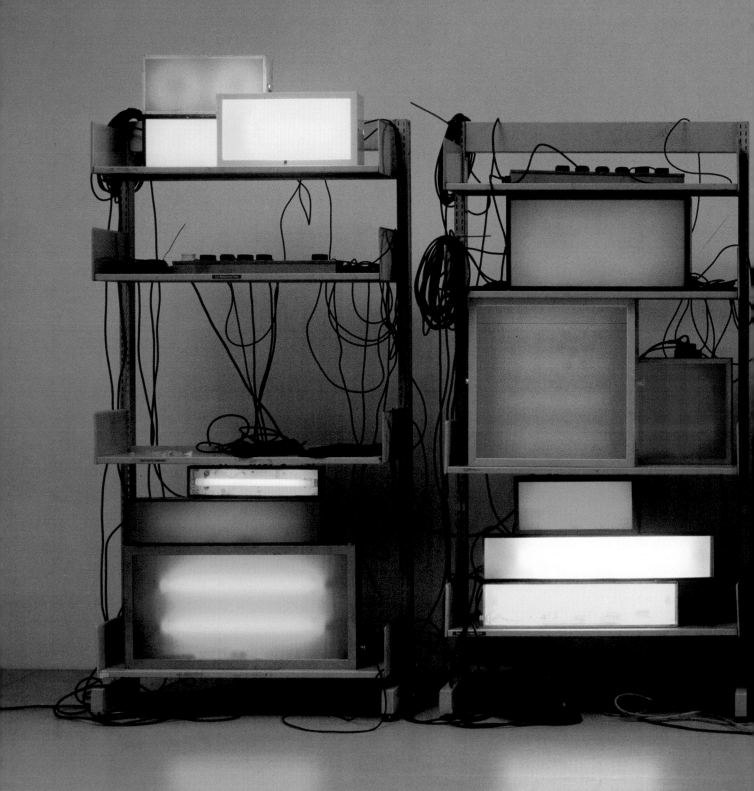

DAVID BATCHELOR
Brick Lane Remix I 2003
Shelving units, found light boxes, fluorescent light, vinyl, acrylic sheet, cable, plugboards
Dimensions variable

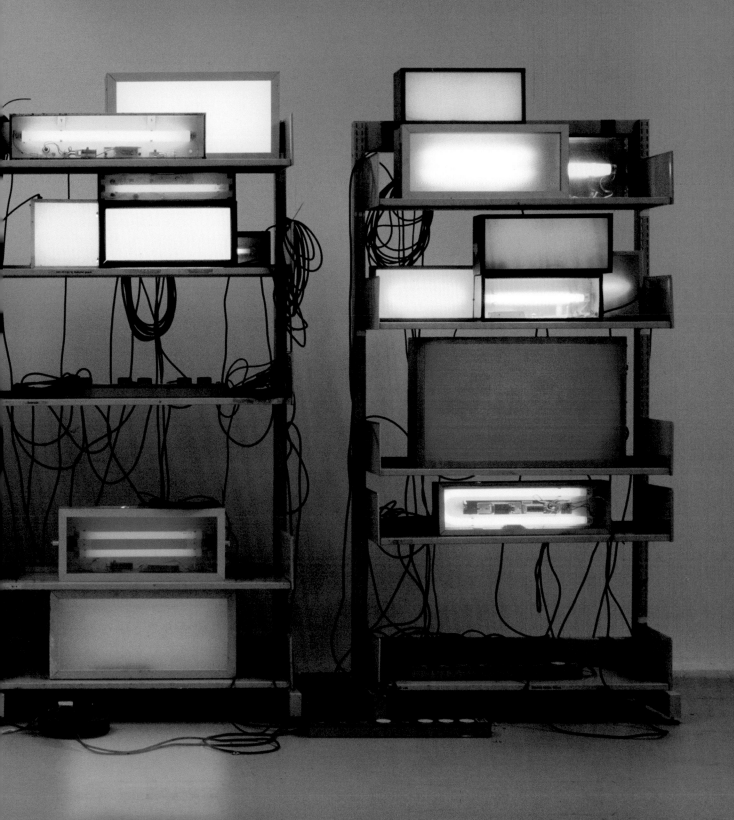

DAVID BATCHELOR
Parapillar 7 2006
Steel support with plastic, metal, rubber, painted wood and feather objects
267 x 78 x 78 cm

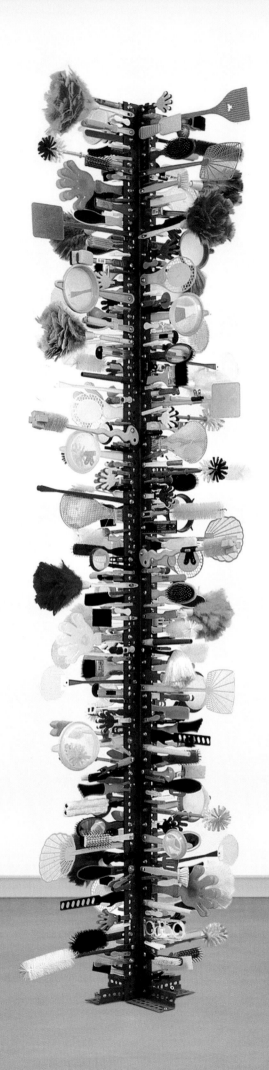

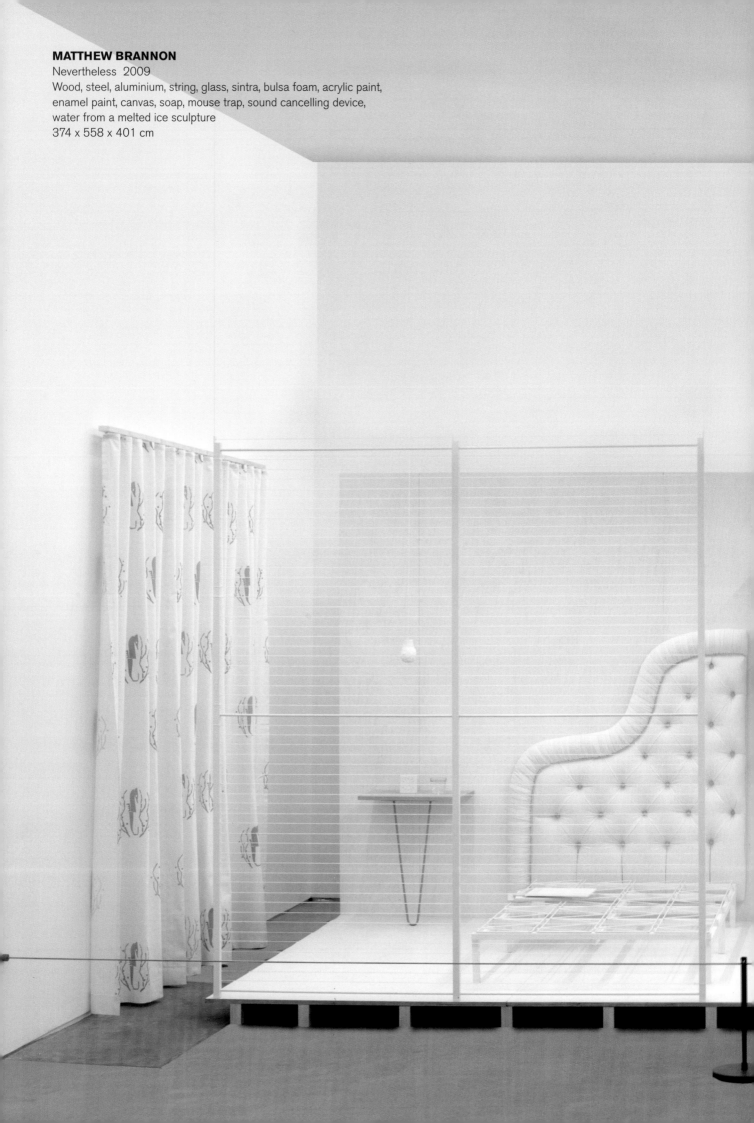

MATTHEW BRANNON
Nevertheless 2009
Wood, steel, aluminium, string, glass, sintra, bulsa foam, acrylic paint,
enamel paint, canvas, soap, mouse trap, sound cancelling device,
water from a melted ice sculpture
374 x 558 x 401 cm

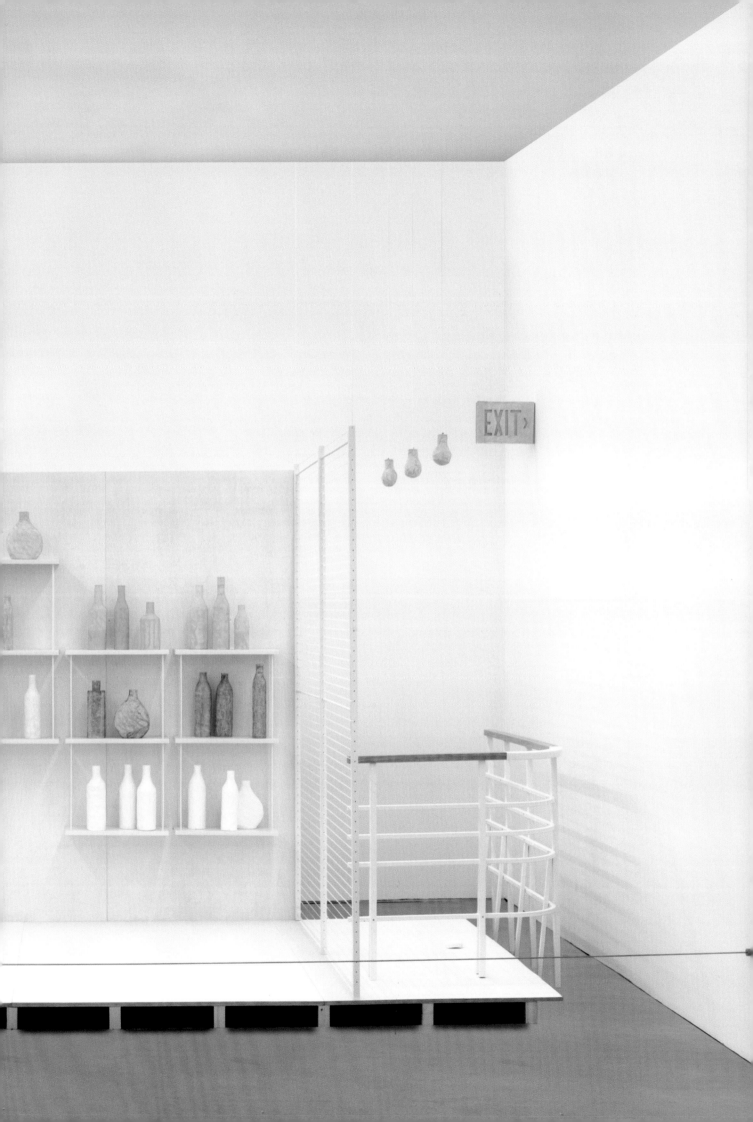

EXIT ›

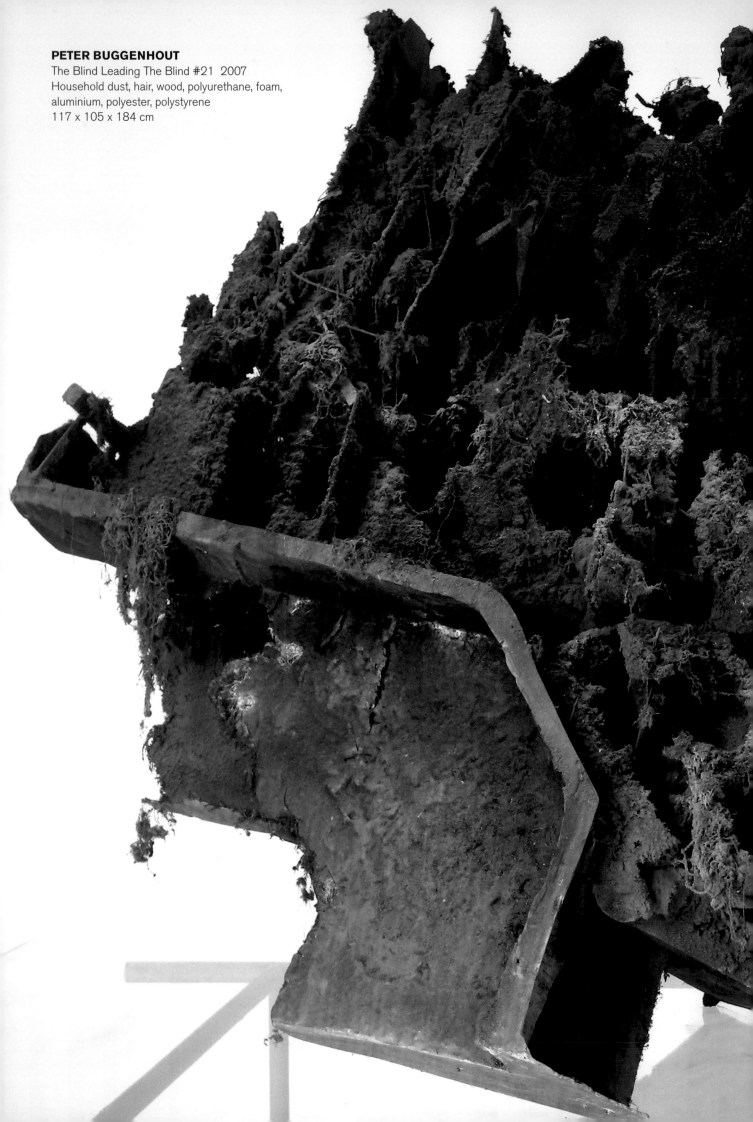

PETER BUGGENHOUT
The Blind Leading The Blind #21 2007
Household dust, hair, wood, polyurethane, foam,
aluminium, polyester, polystyrene
117 x 105 x 184 cm

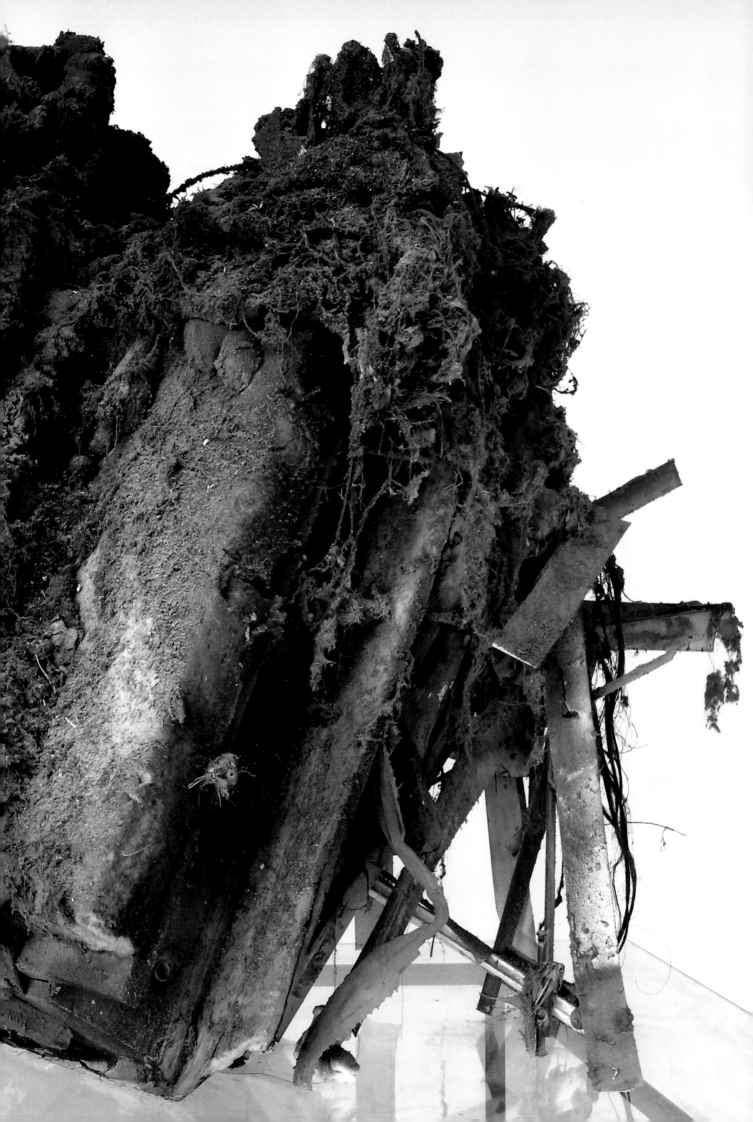

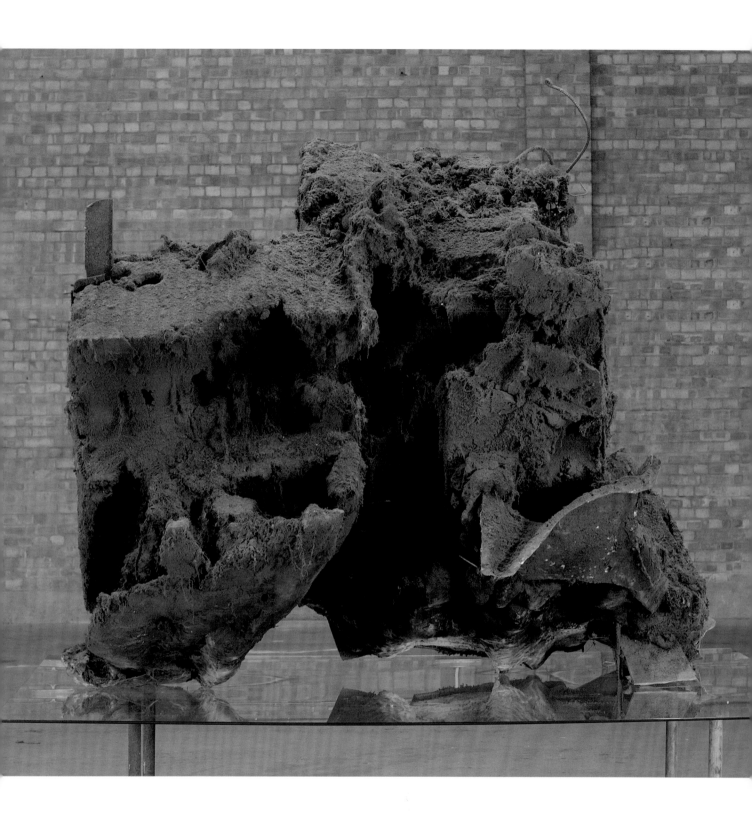

PETER BUGGENHOUT
The Blind Leading The Blind #26 2008
Mixed media and disposable material covered with household dust
134.5 x 166 x 150 cm

PETER BUGGENHOUT
Eskimo Blues II 1999
Treated cow stomach
100 x 145 x 75 cm

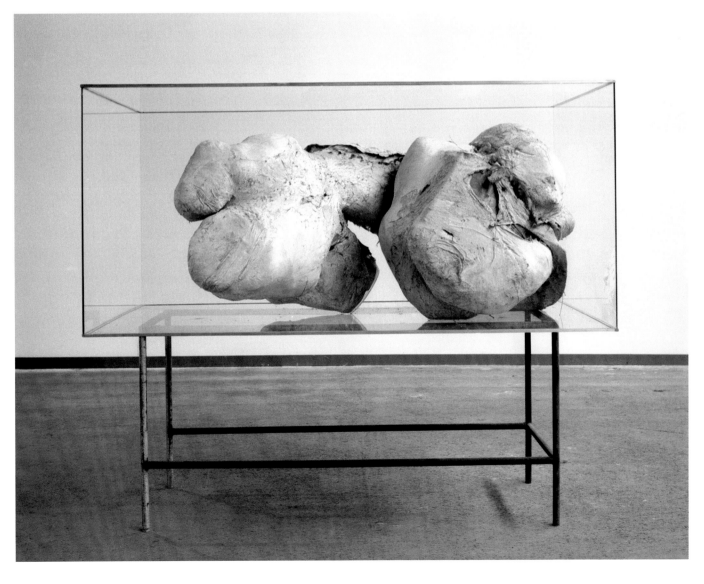

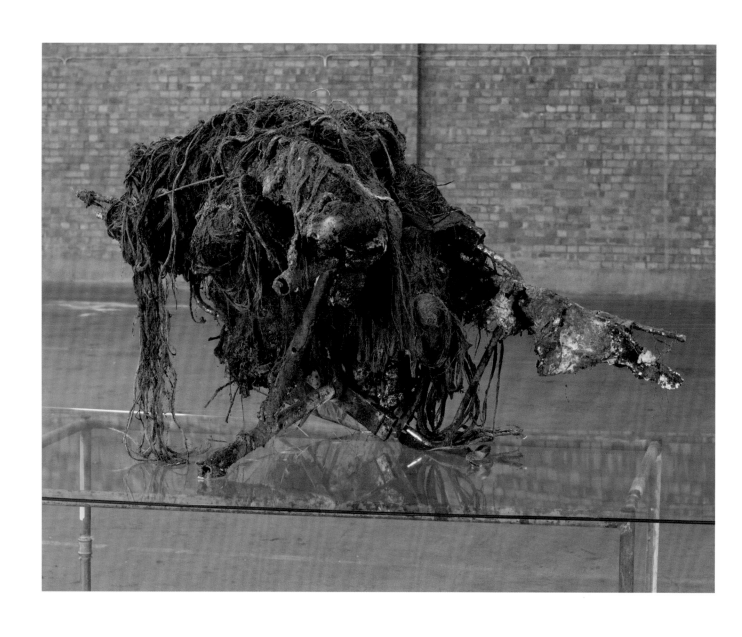

PETER BUGGENHOUT
Gorgo #4 2005
Blood, pigment, iron, wood, paper, glass
83 x 148 x 92 cm

PETER BUGGENHOUT
Gorgo #14 2007
Horse hair, blood, polyester, epoxy, polyurethane, iron, aluminium
126.5 x 162 x 88 cm

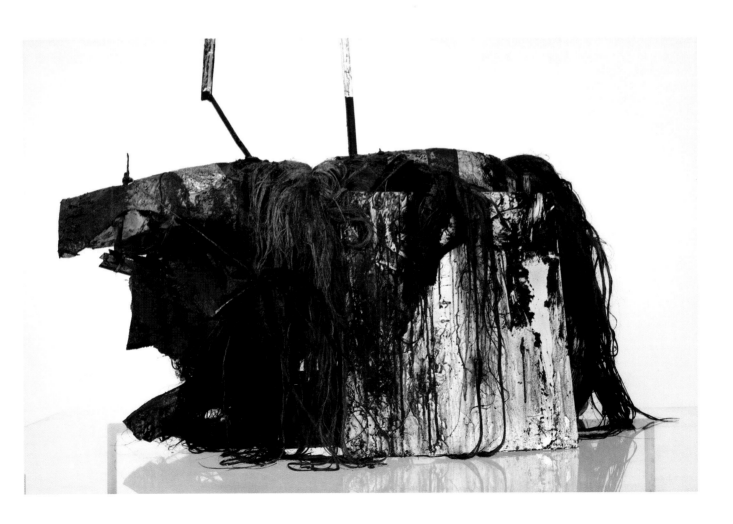

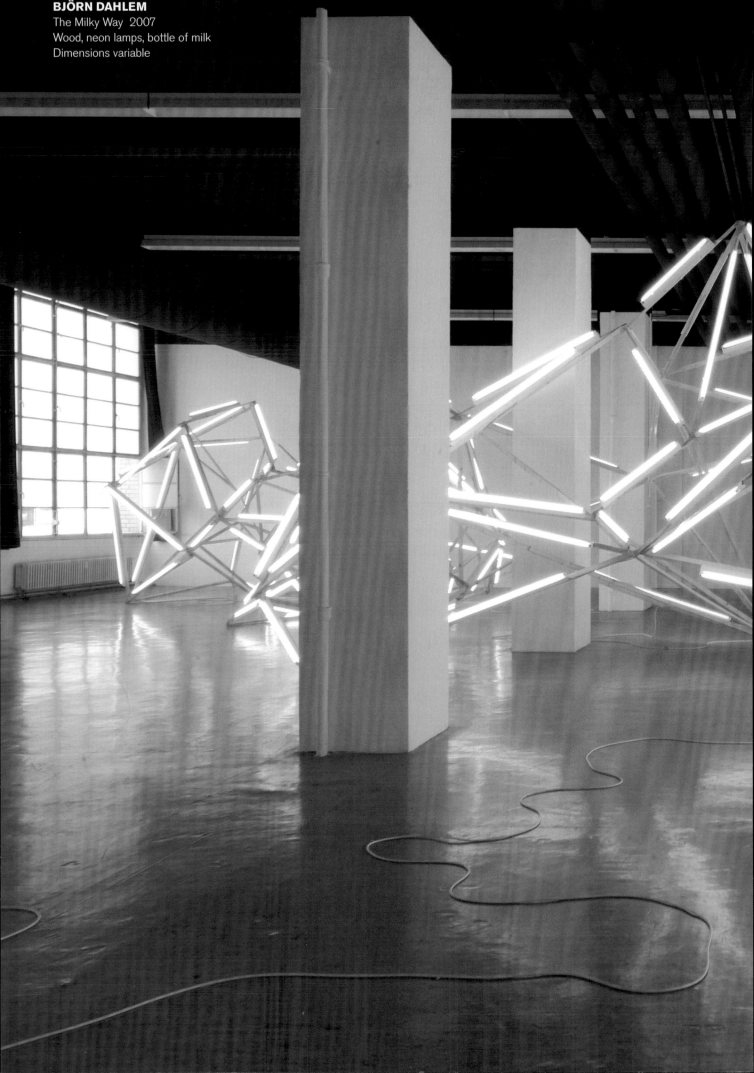

BJÖRN DAHLEM
The Milky Way 2007
Wood, neon lamps, bottle of milk
Dimensions variable

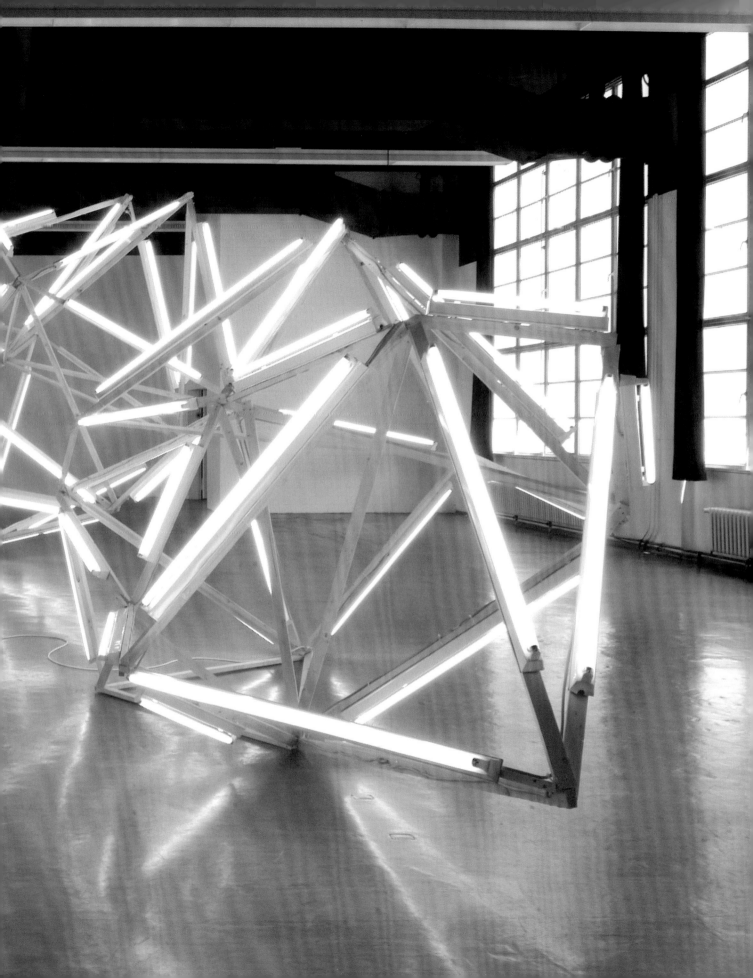

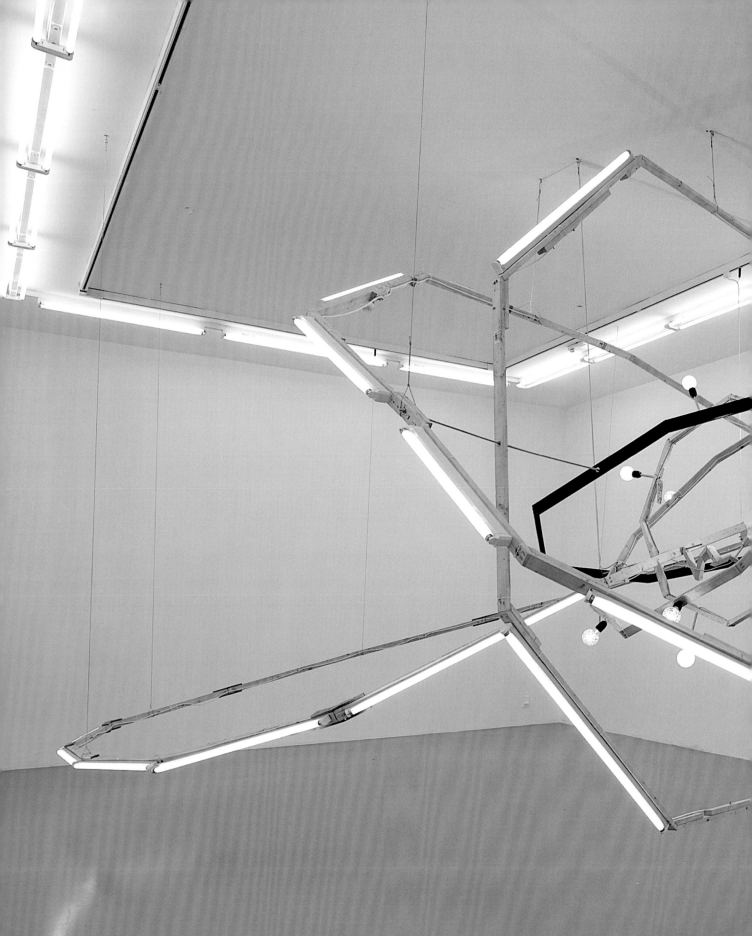

BJÖRN DAHLEM
Schwarzes Loch (M-Sphären) 2007
Wood, lamps, light bulbs and neon lamps
540 x 730 x 360 cm

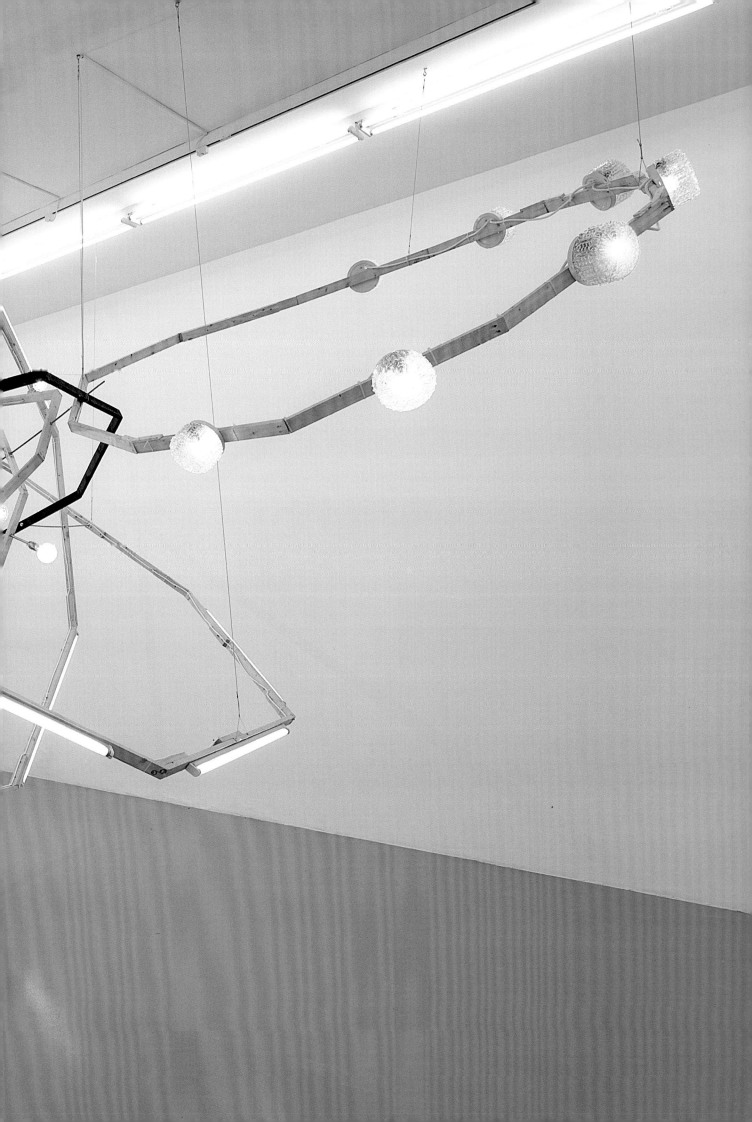

BJÖRN DAHLEM
Cathedral 2008
Wood, lightbulbs, glacier cherries, red wine, varnish
191 x 60 x 60 cm

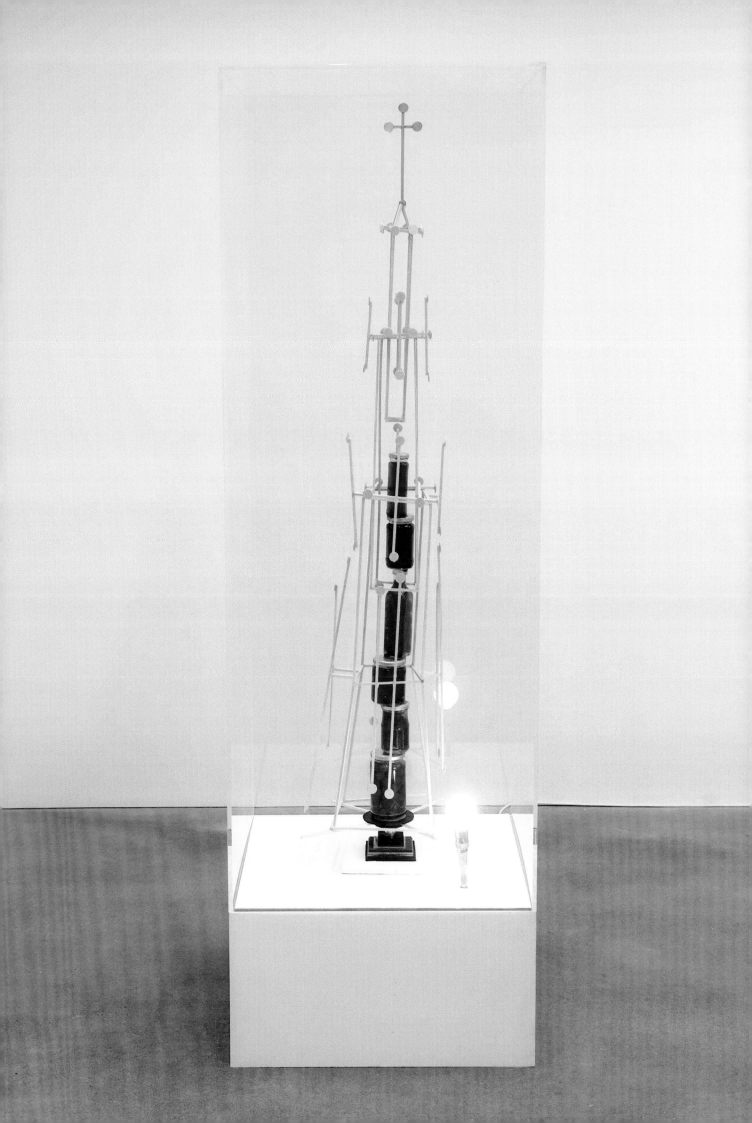

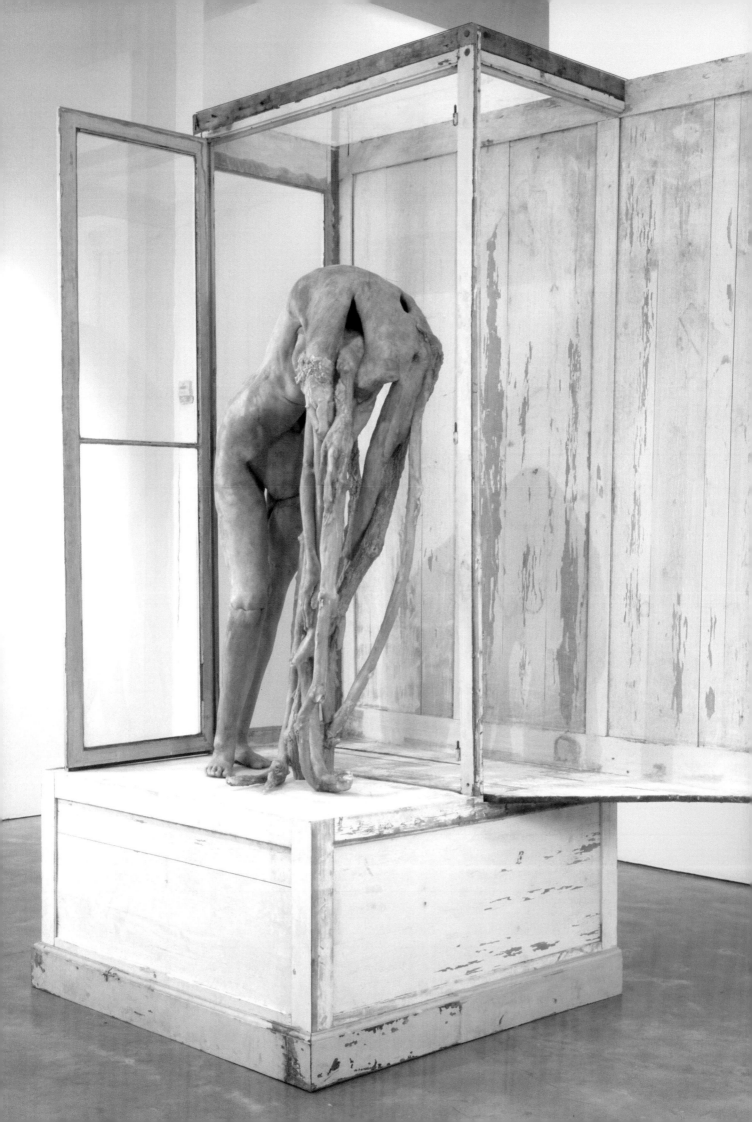

BERLINDE DE BRUYCKERE
Marthe 2008
Wax, epoxy, metal, wood and glass
280 x 172.5 x 119.5 cm

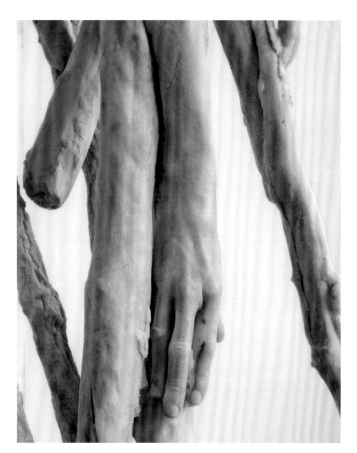 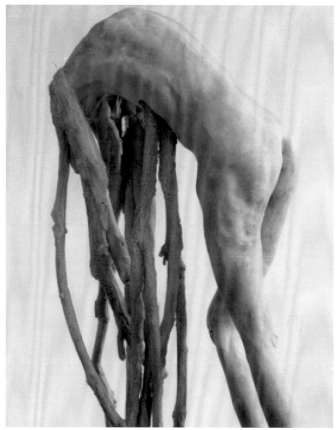

BERLINDE DE BRUYCKERE
Marthe 2008 (details)

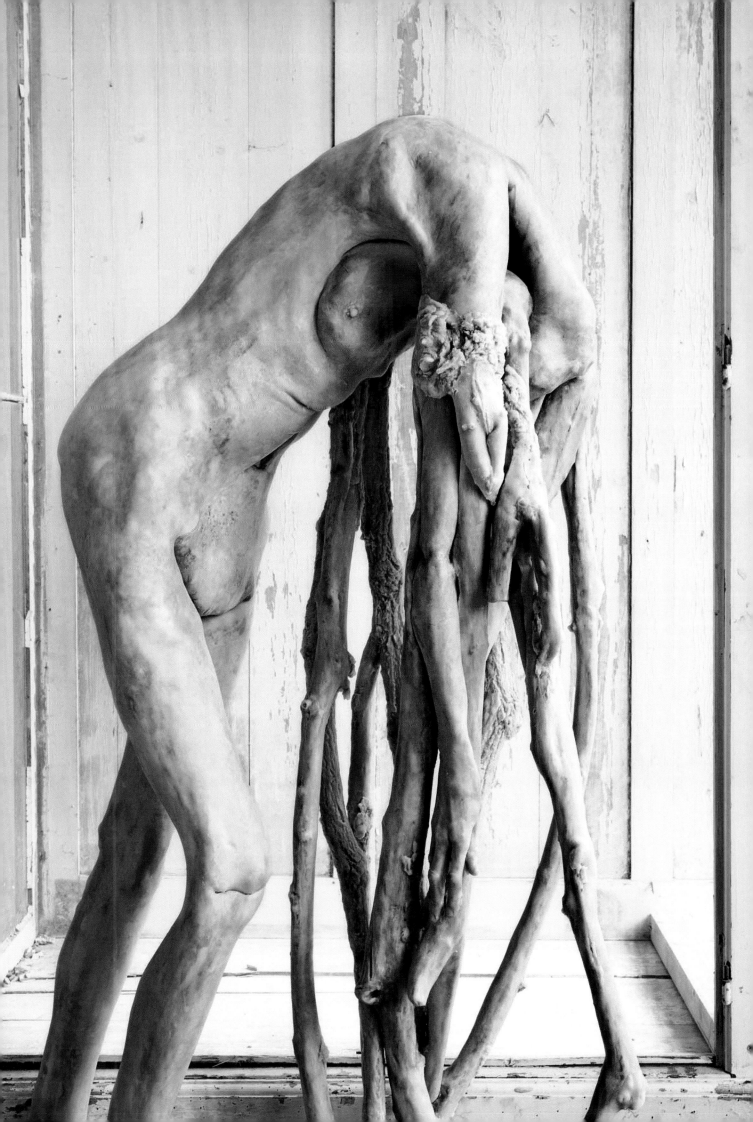

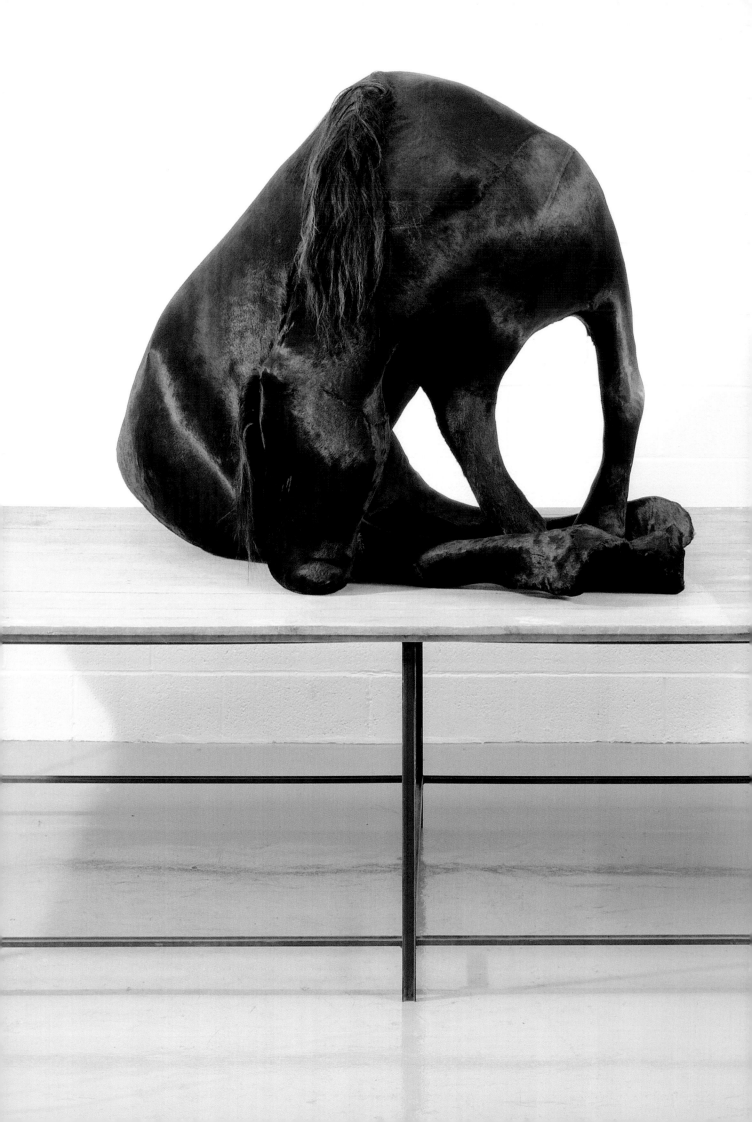

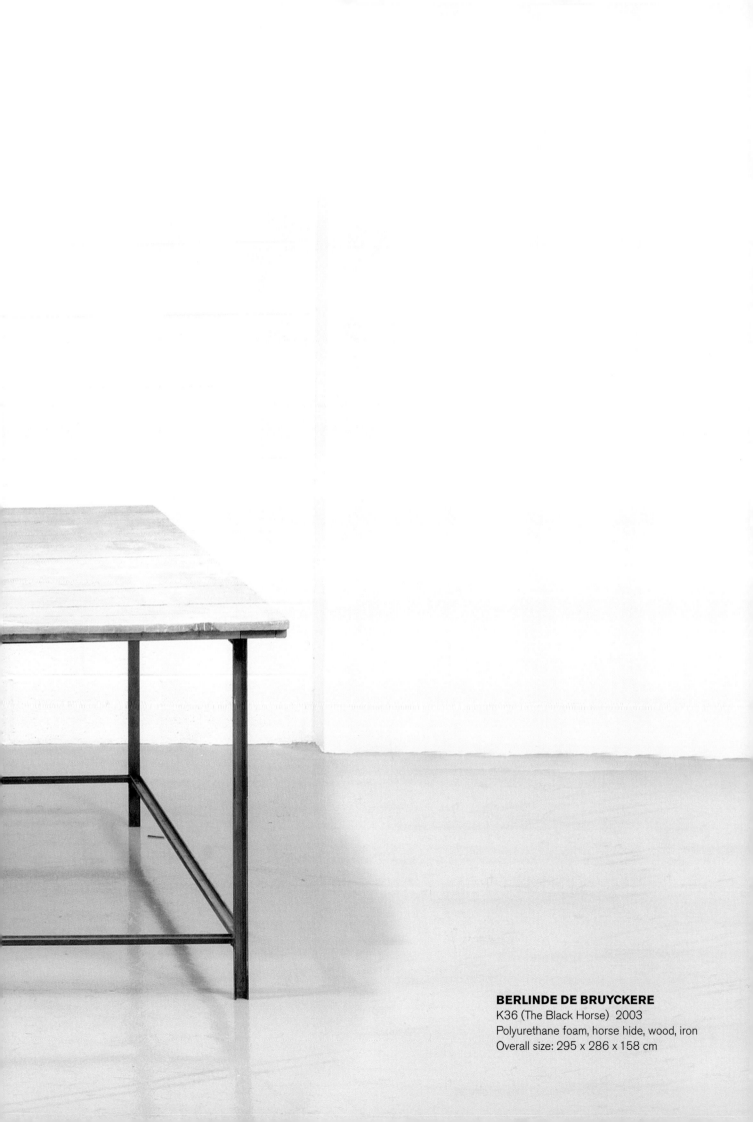

BERLINDE DE BRUYCKERE
K36 (The Black Horse) 2003
Polyurethane foam, horse hide, wood, iron
Overall size: 295 x 286 x 158 cm

BERLINDE DE BRUYCKERE
K21 2006
Horse skin, horse hair, epoxy resin, iron, wood, glass
Overall size: 193 x 177 x 96 cm

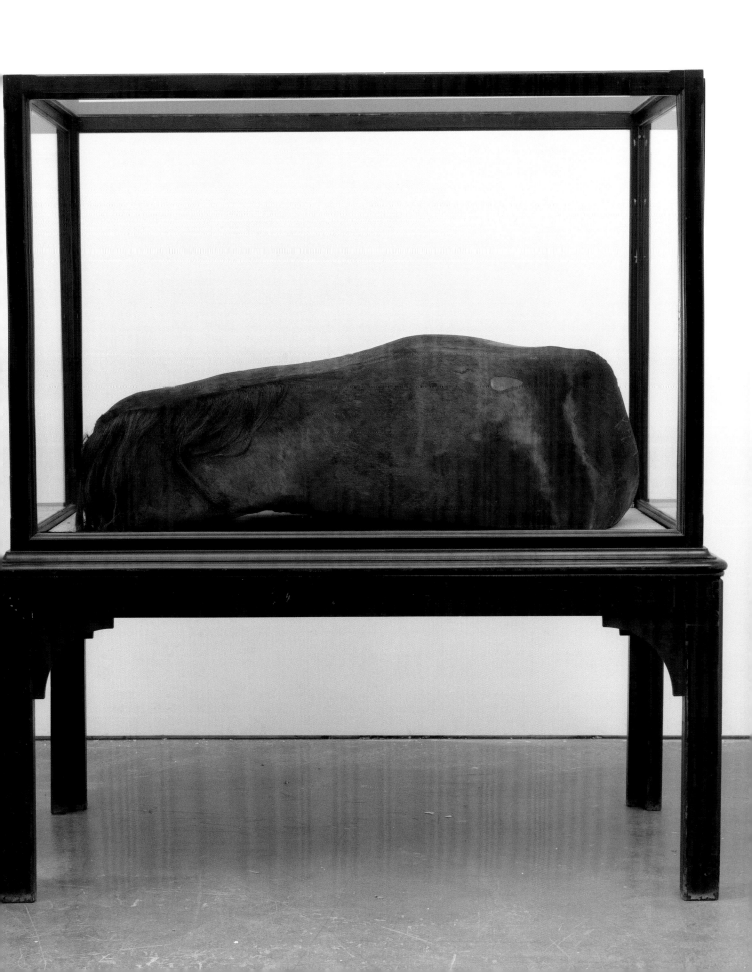

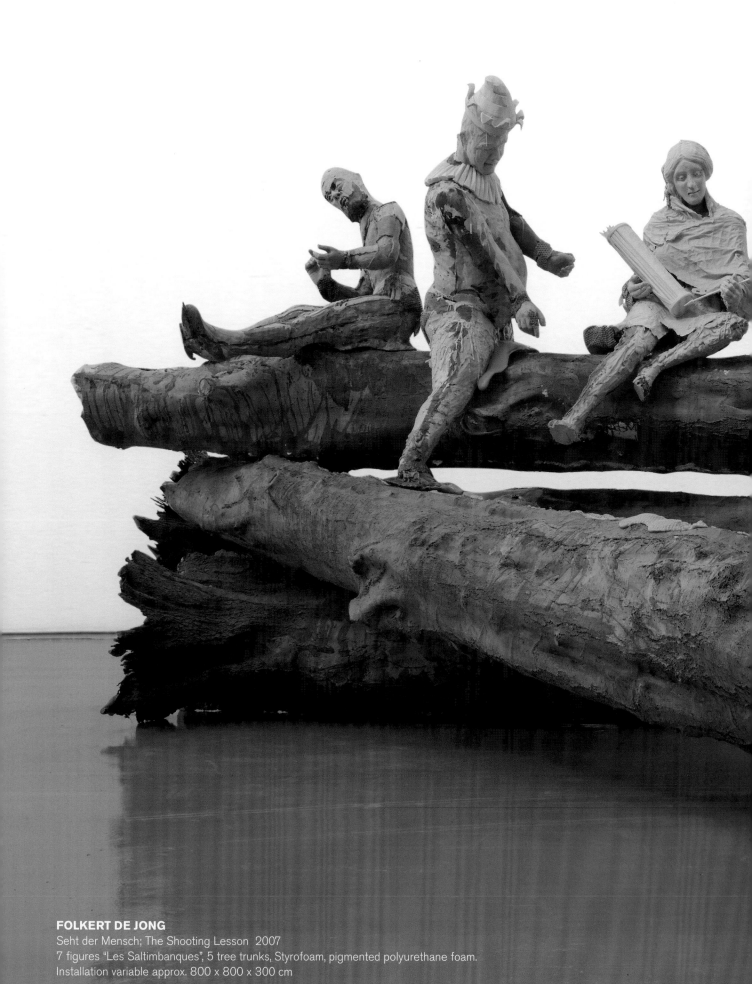

FOLKERT DE JONG
Seht der Mensch; The Shooting Lesson 2007
7 figures "Les Saltimbanques", 5 tree trunks, Styrofoam, pigmented polyurethane foam.
Installation variable approx. 800 x 800 x 300 cm

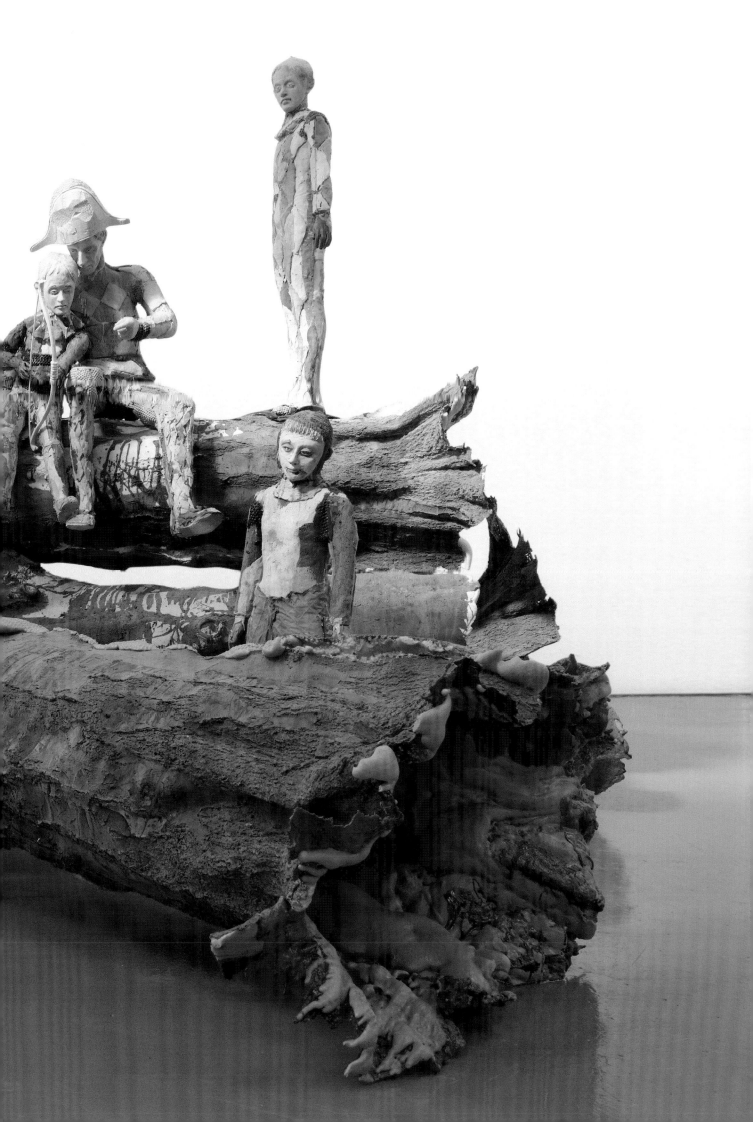

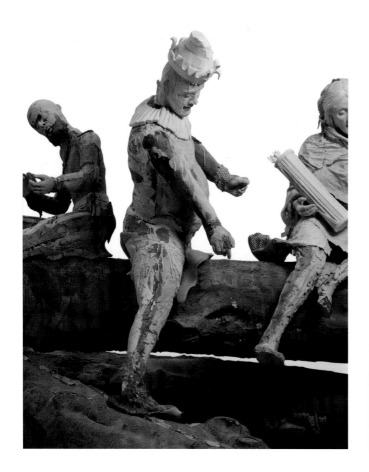
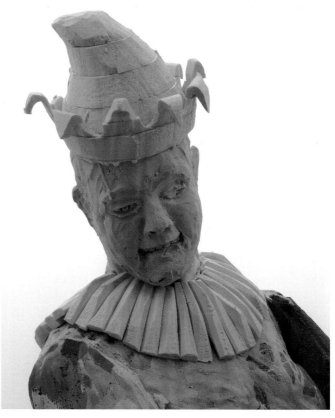
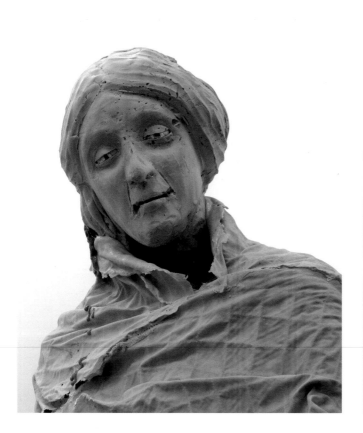
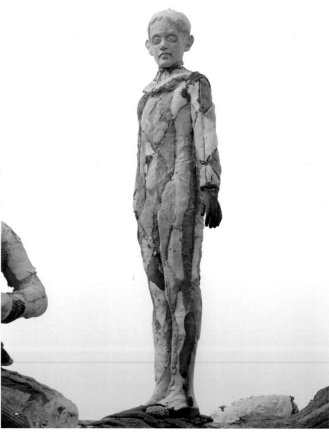

FOLKERT DE JONG
The Shooting Lesson 2007 (details)

40

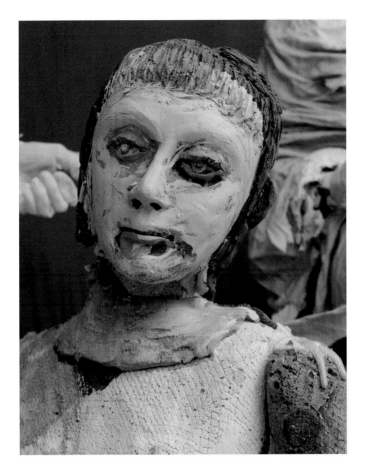

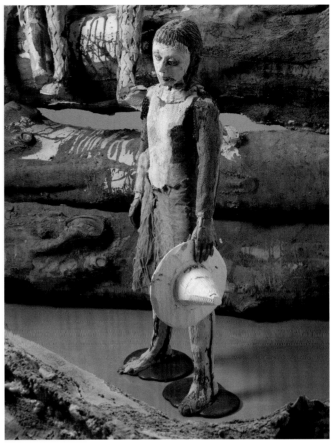

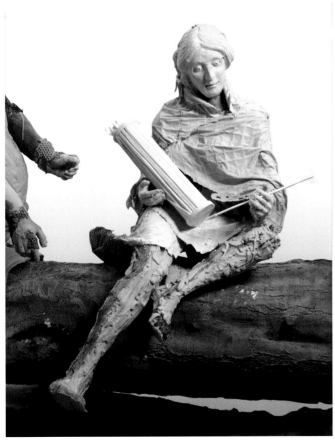

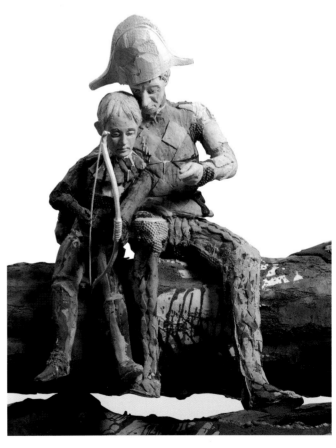

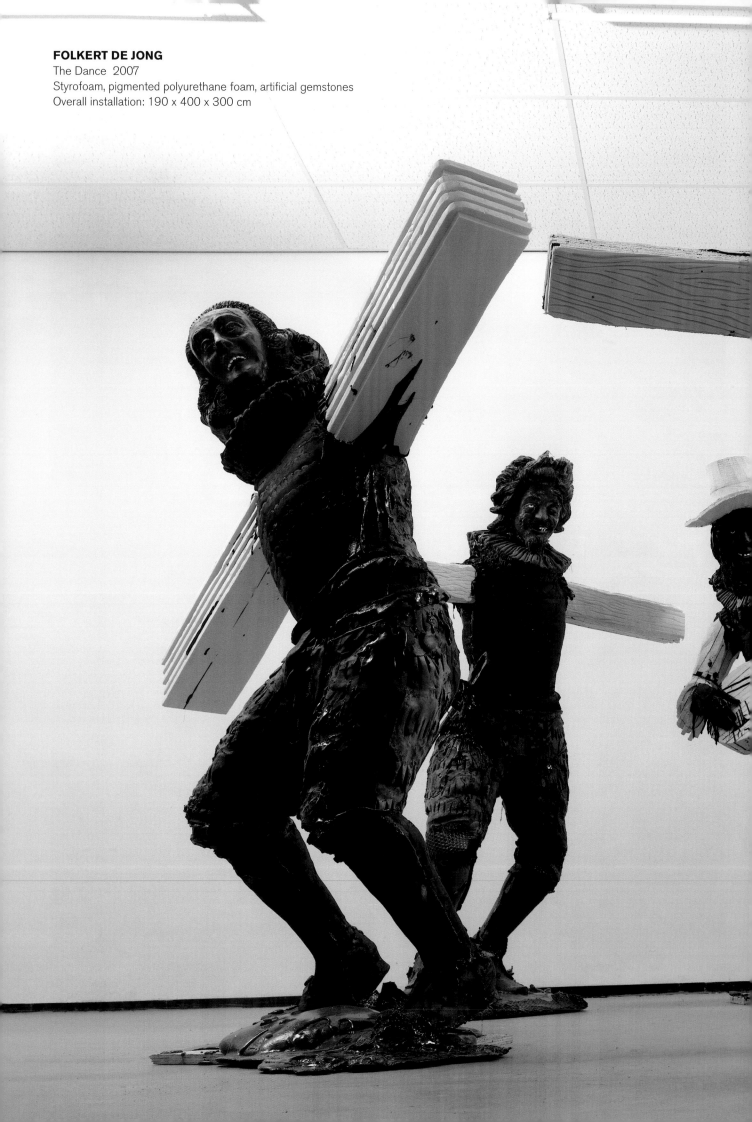

FOLKERT DE JONG
The Dance 2007
Styrofoam, pigmented polyurethane foam, artificial gemstones
Overall installation: 190 x 400 x 300 cm

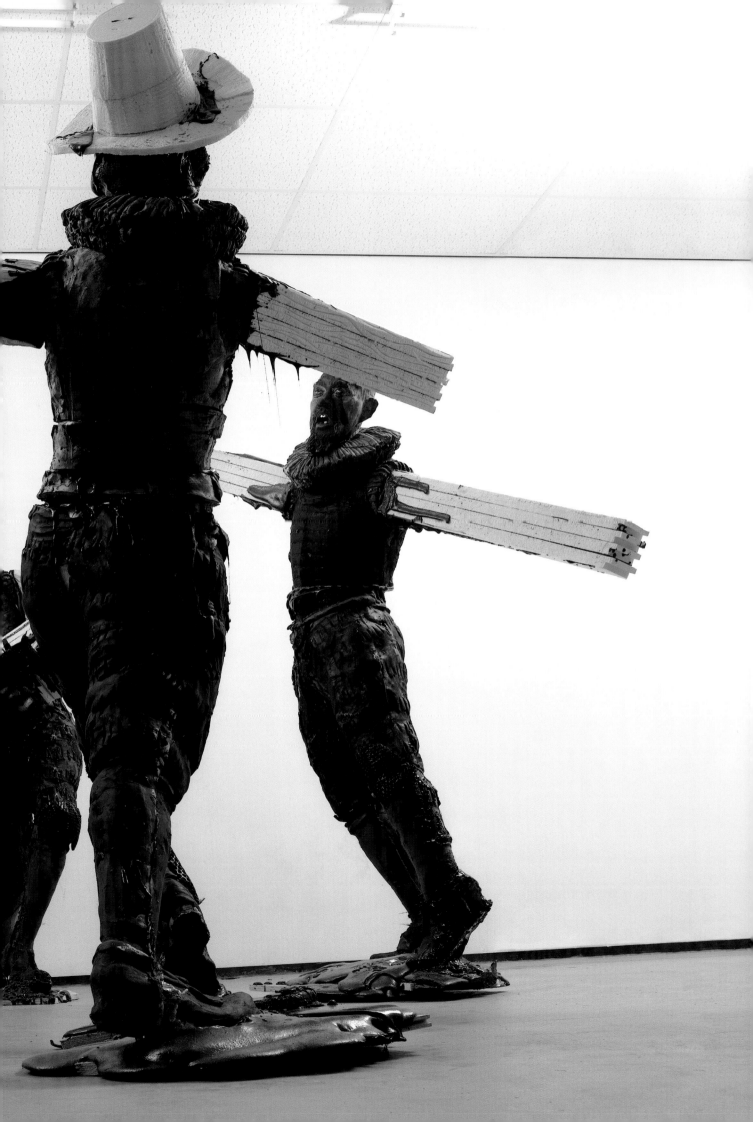

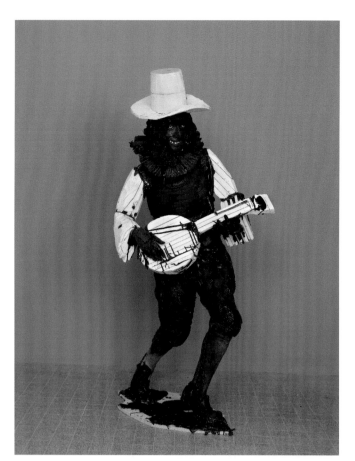

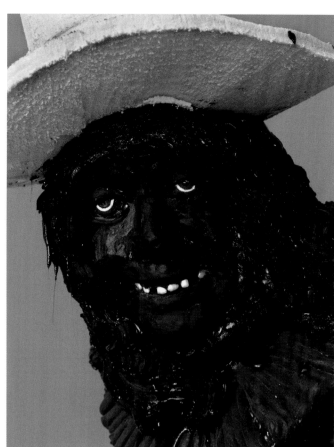

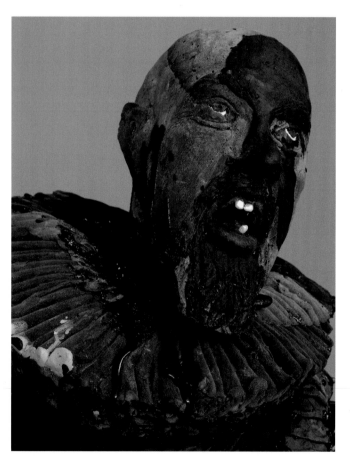

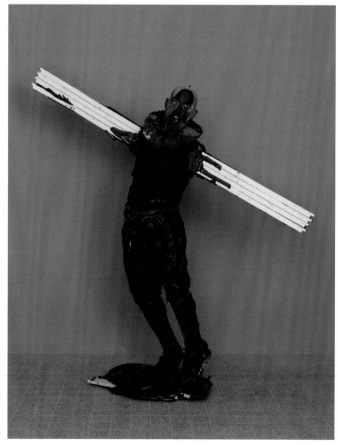

FOLKERT DE JONG
The Dance 2007 (details)

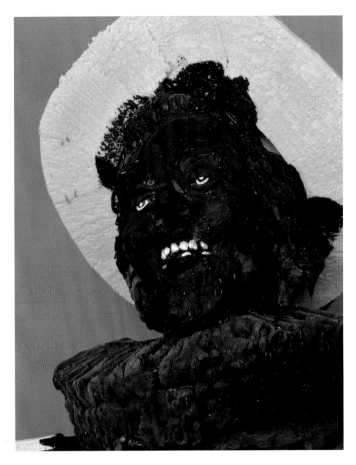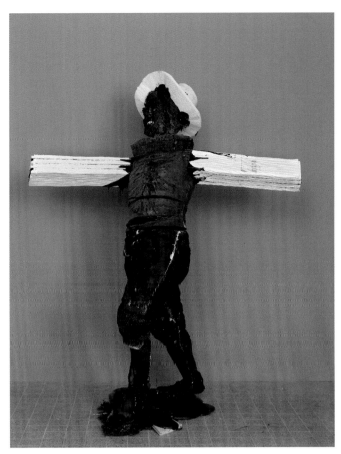
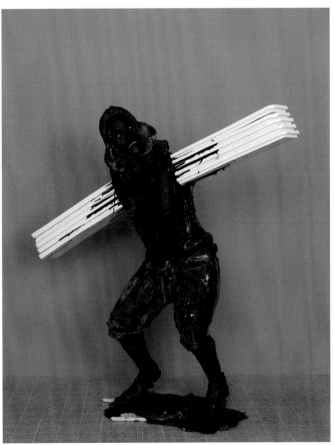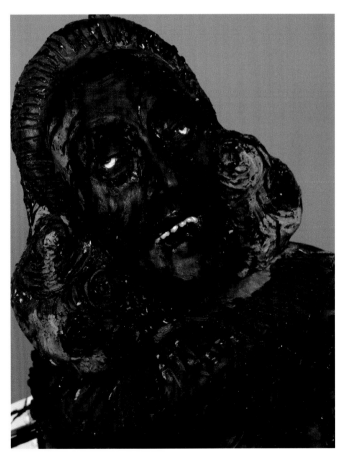

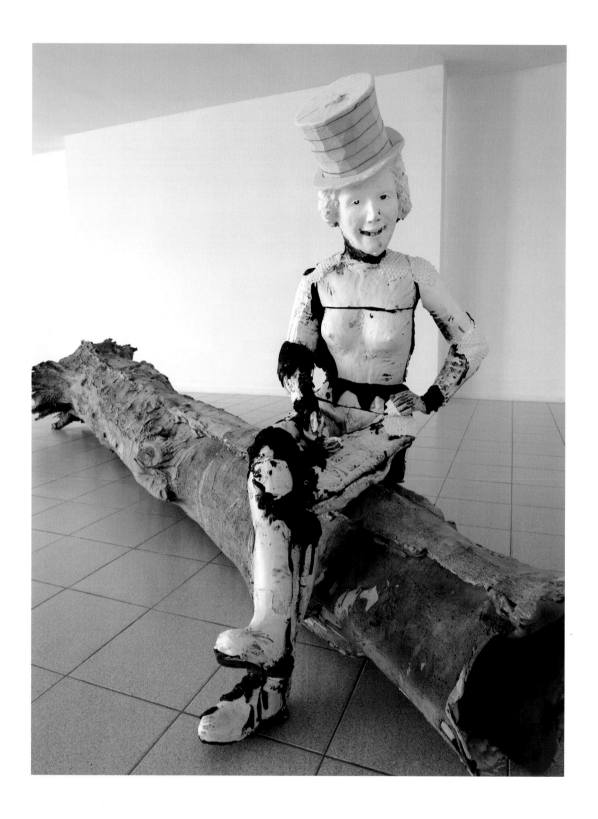

FOLKERT DE JONG

above:
The Peckhamian Mimic: "First Commandment" 2007
Styrofoam, pigmented polyurethane foam, artificial gemstones
Log approx: 90 x 530 x 105 cm Figure: 158 x 40 x 105 cm

right:
Asalto de la Diligencia 2008
Styrofoam, pigmented polyurethane foam, coloured acrylic sheets
300 x 120 x 300 cm

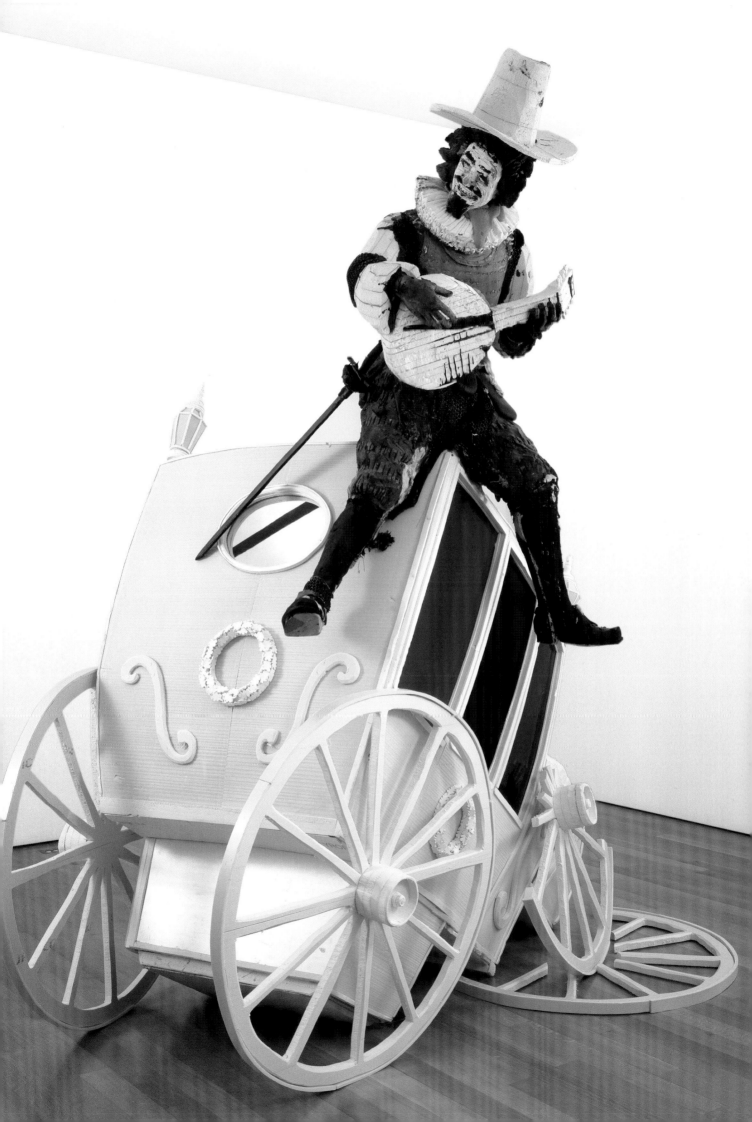

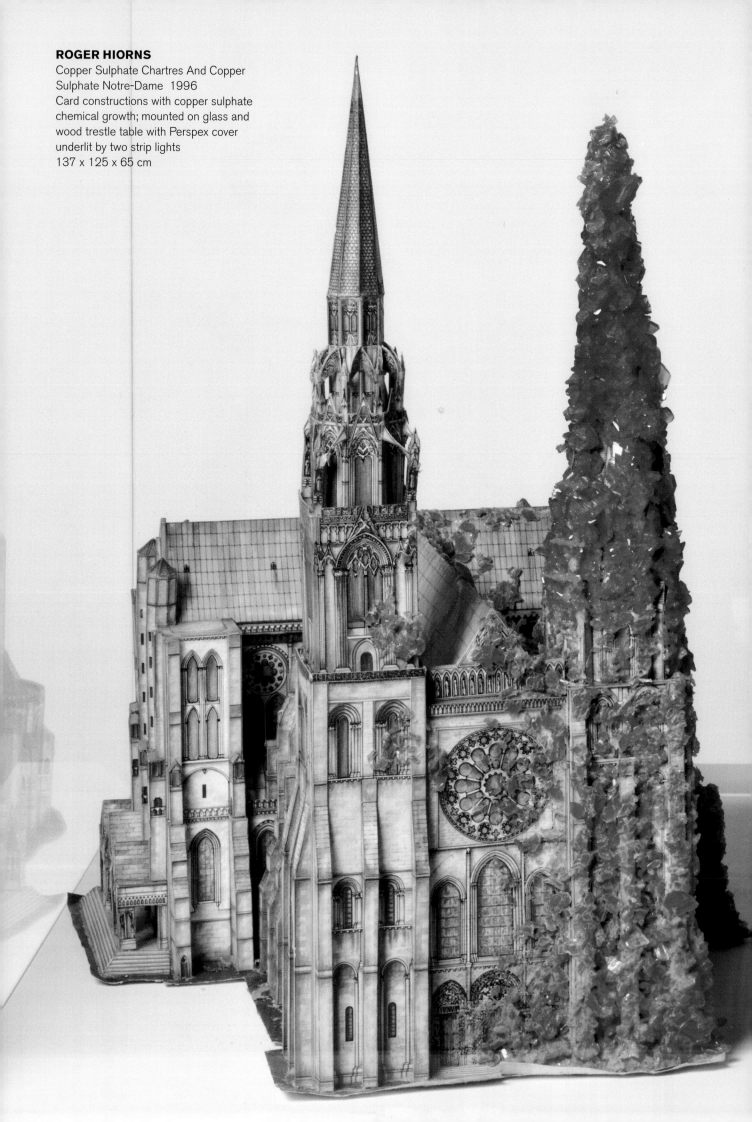

ROGER HIORNS
Copper Sulphate Chartres And Copper
Sulphate Notre-Dame 1996
Card constructions with copper sulphate
chemical growth; mounted on glass and
wood trestle table with Perspex cover
underlit by two strip lights
137 x 125 x 65 cm

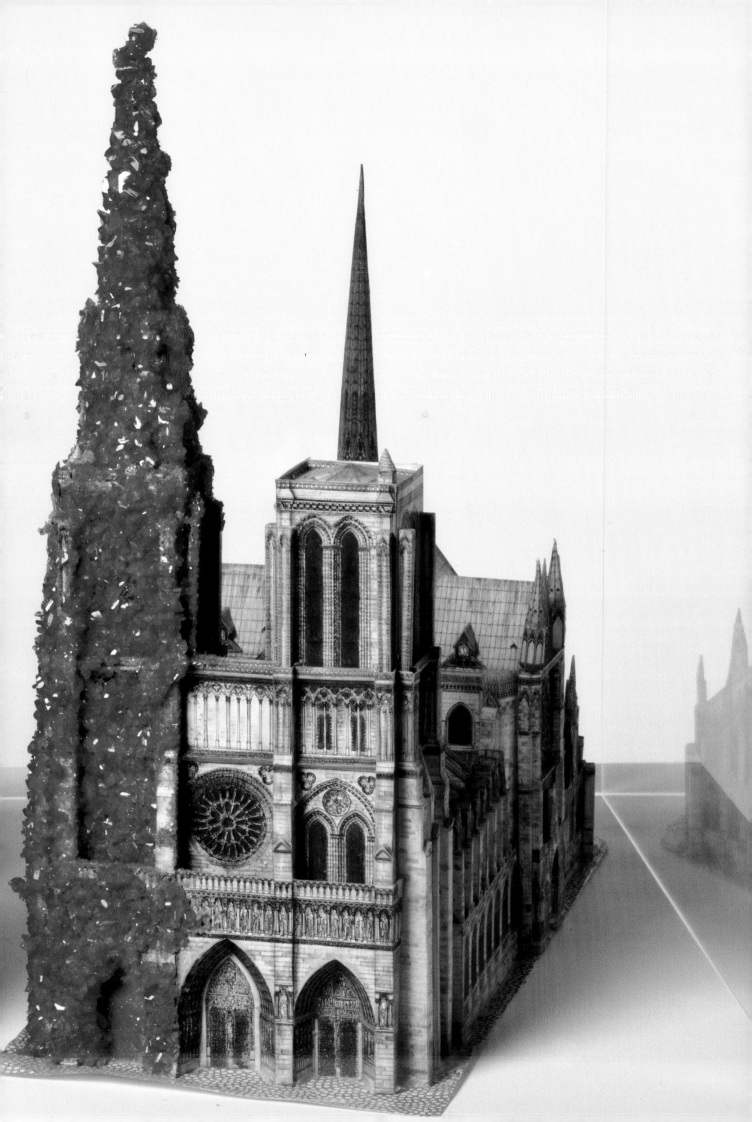

ROGER HIORNS
Leaning Chartres With Cobalt And Copper Crystals 1996
Card construction with cobalt and copper chemical growth.
Mounted on glass and wood trestle table with Perspex cover
underlit by two strip lights
137 x 125 x 65 cm

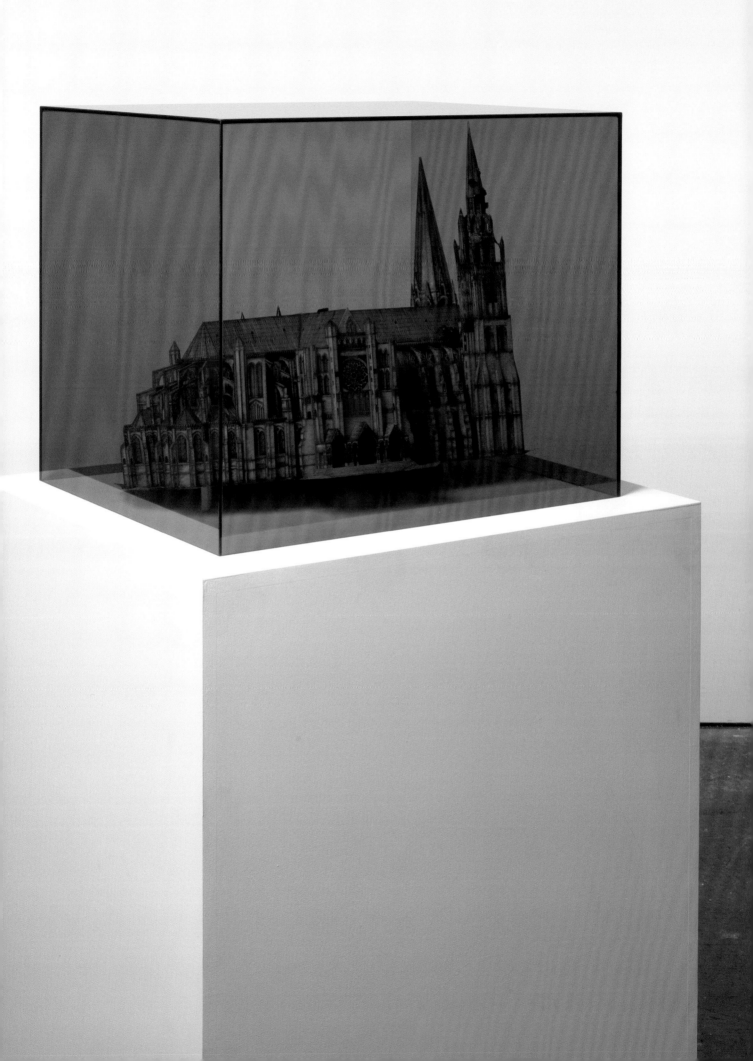

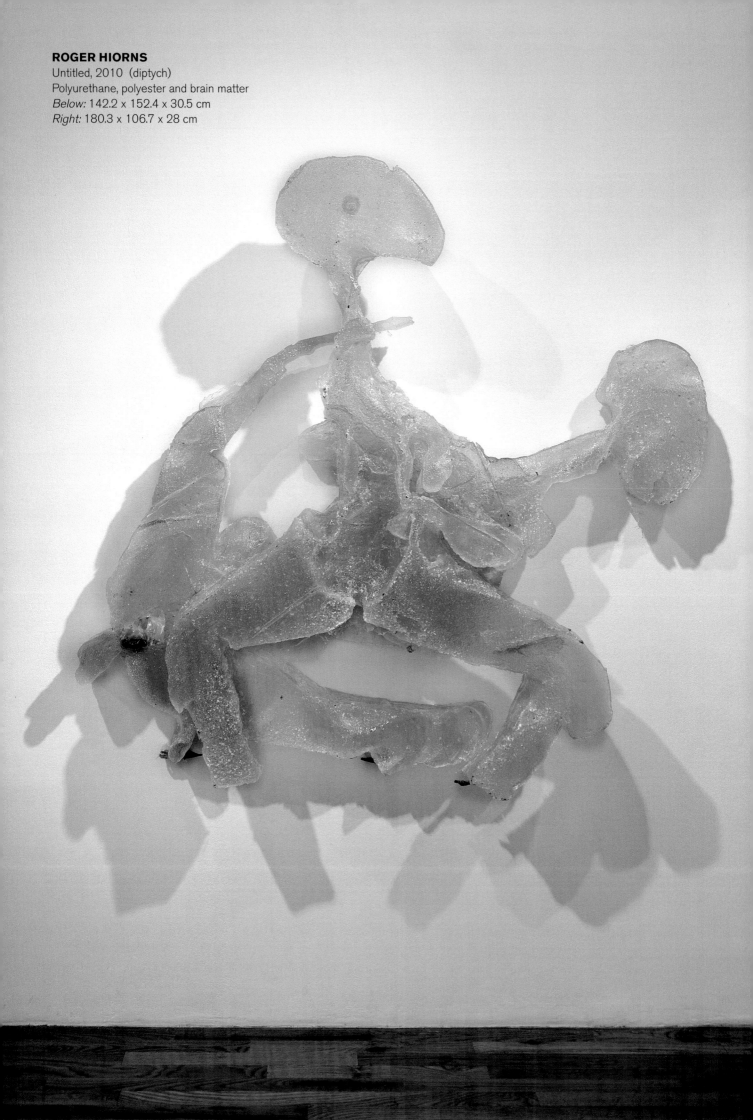

ROGER HIORNS
Untitled, 2010 (diptych)
Polyurethane, polyester and brain matter
Below: 142.2 x 152.4 x 30.5 cm
Right: 180.3 x 106.7 x 28 cm

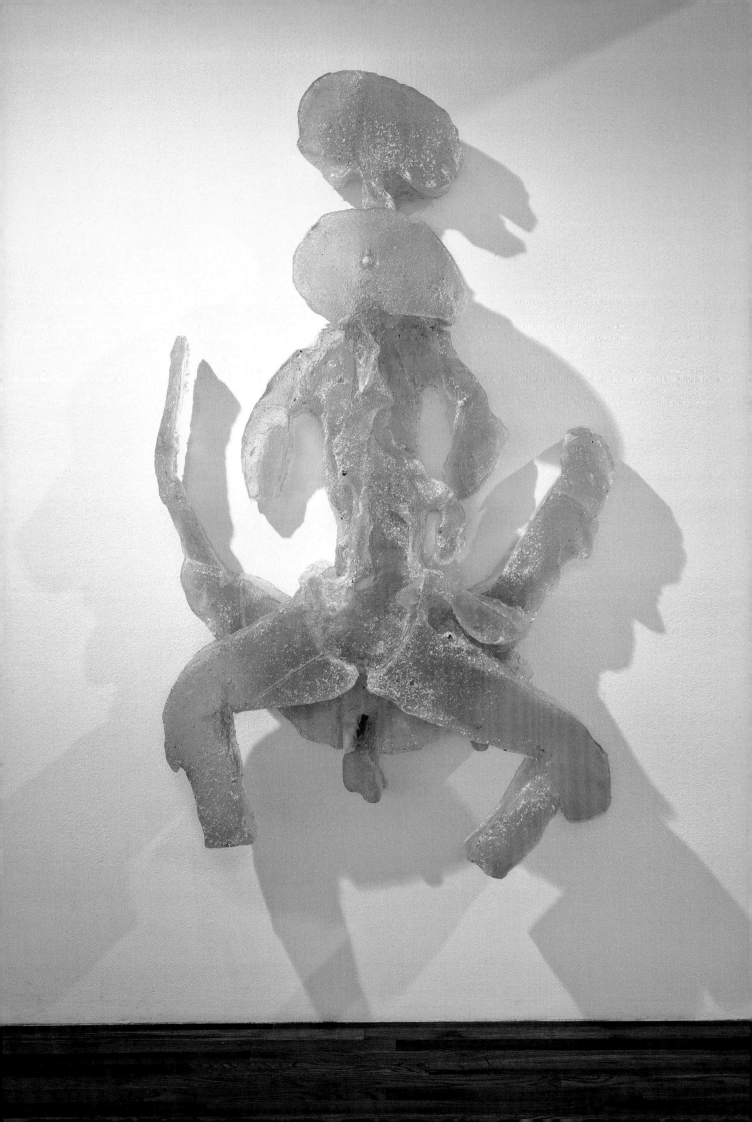

MARTIN HONERT
Riesen (Giants) 2007
Styrodur, polyurethane rubber, wool, clothing, leather
300 x 100 x 80 cm

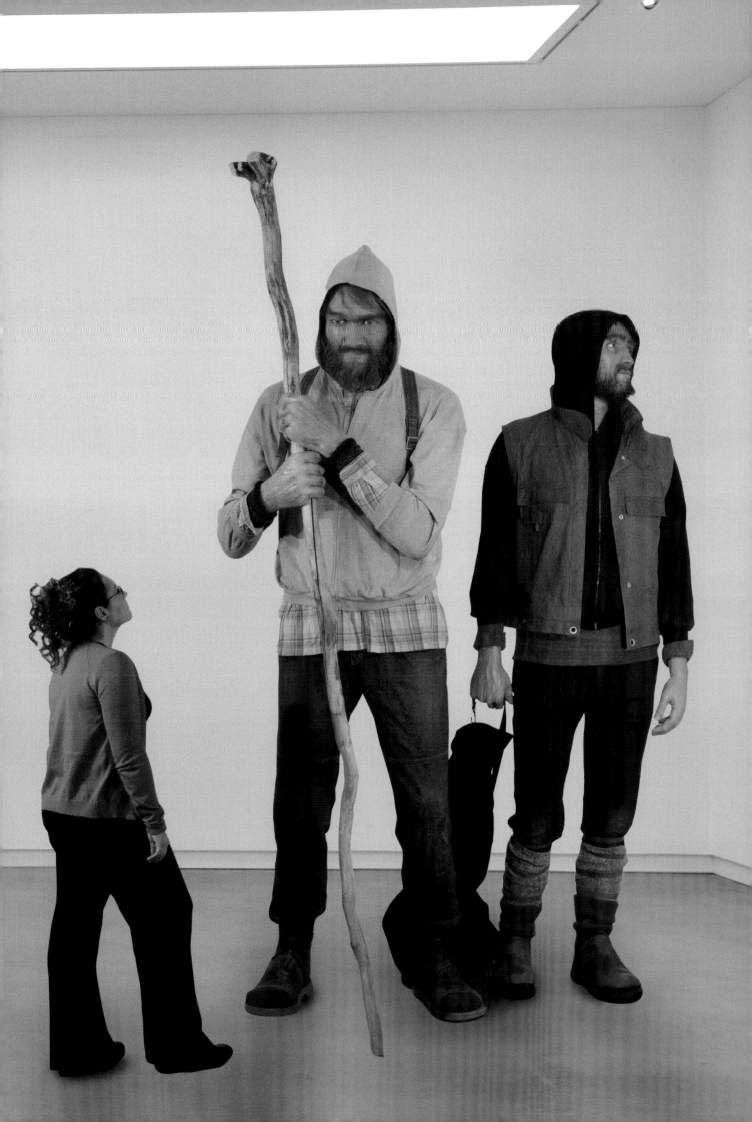

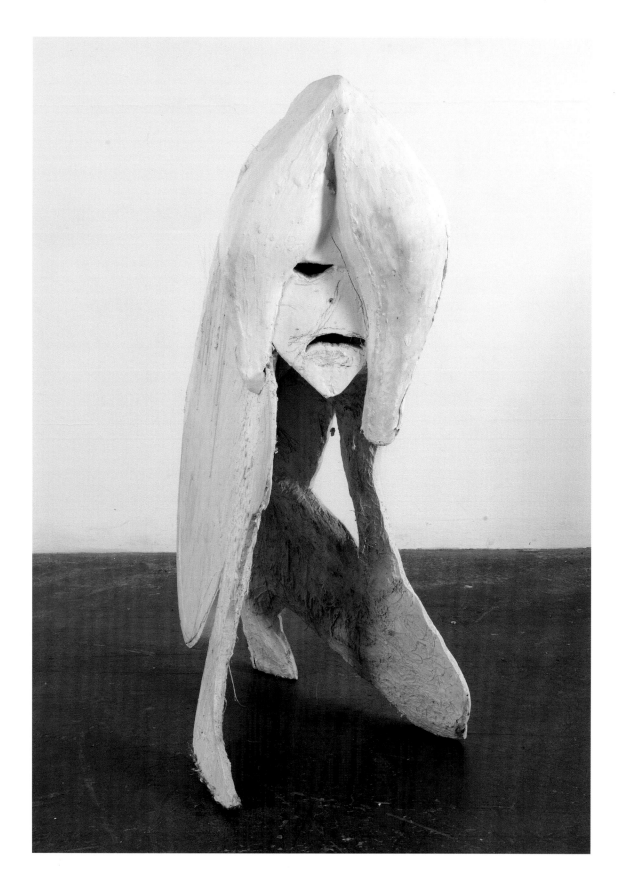

THOMAS HOUSEAGO
above:
Joanne 2005
Plaster, hemp, steel, graphite
124.5 x 58.4 x 86.4 cm

right:
Figure 1 2008
Wood, graphite, tuf-cal, hemp, iron, oil stick
221 x 221 x 132.1 cm

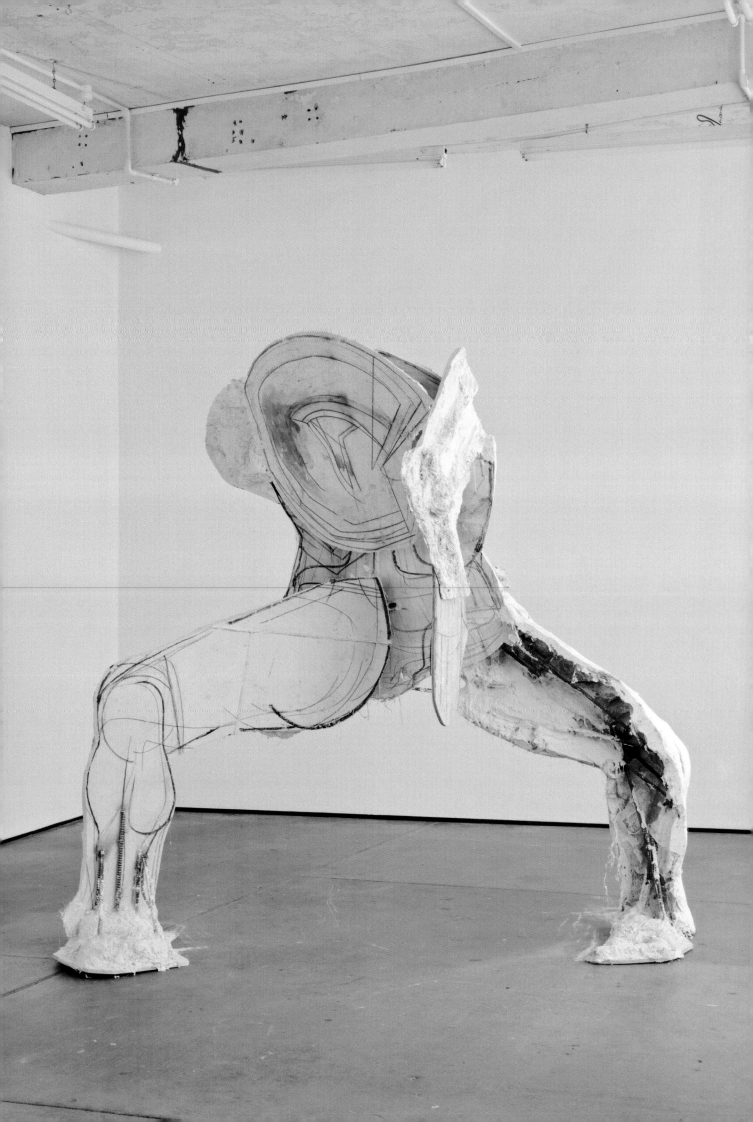

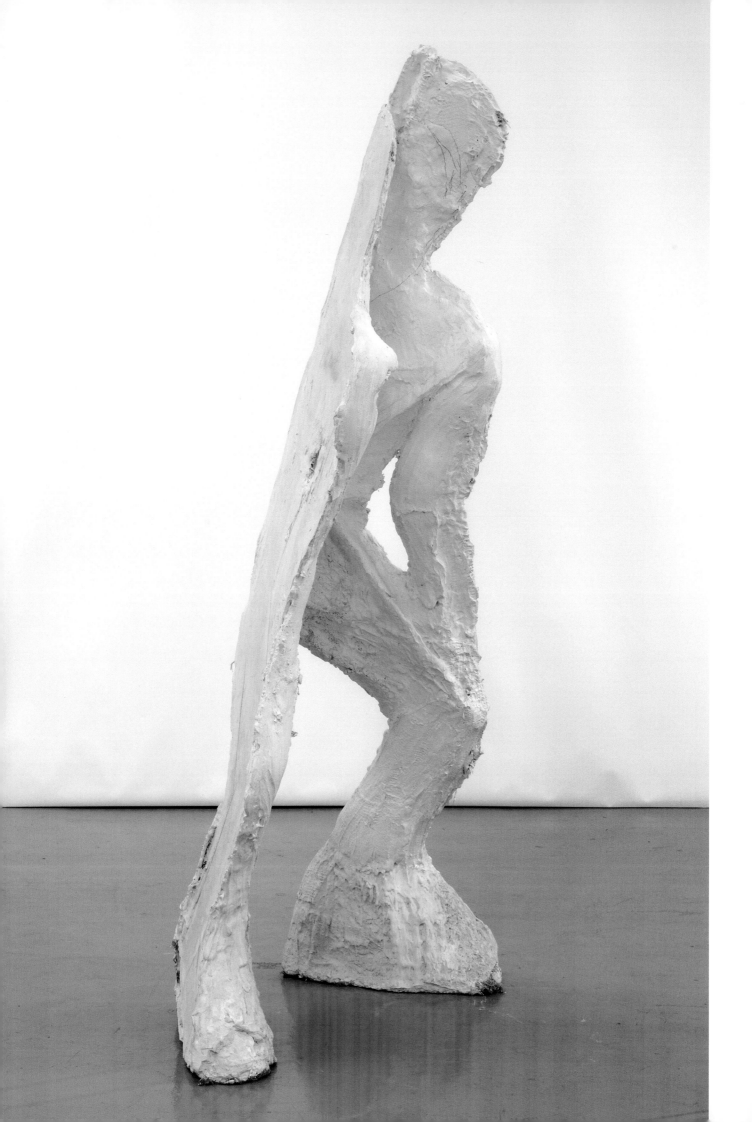

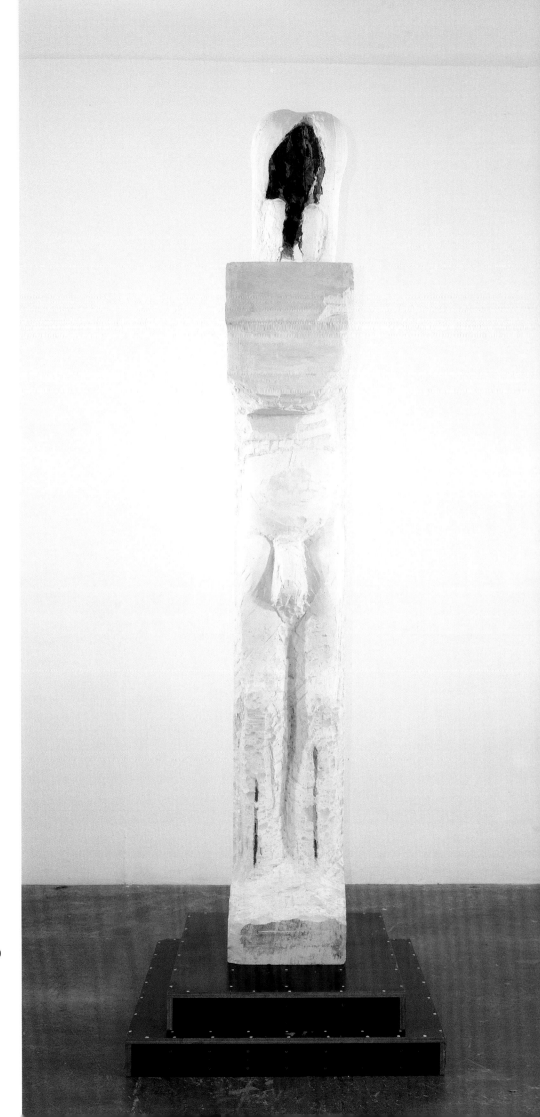

THOMAS HOUSEAGO
right:
Caryatide With Squatting Man 2000
Wood, plaster, iron, jute
300 x 90 x 40 cm

left:
Folded Man 1997
Plaster, jute, inox
220 x 110 x 80 cm

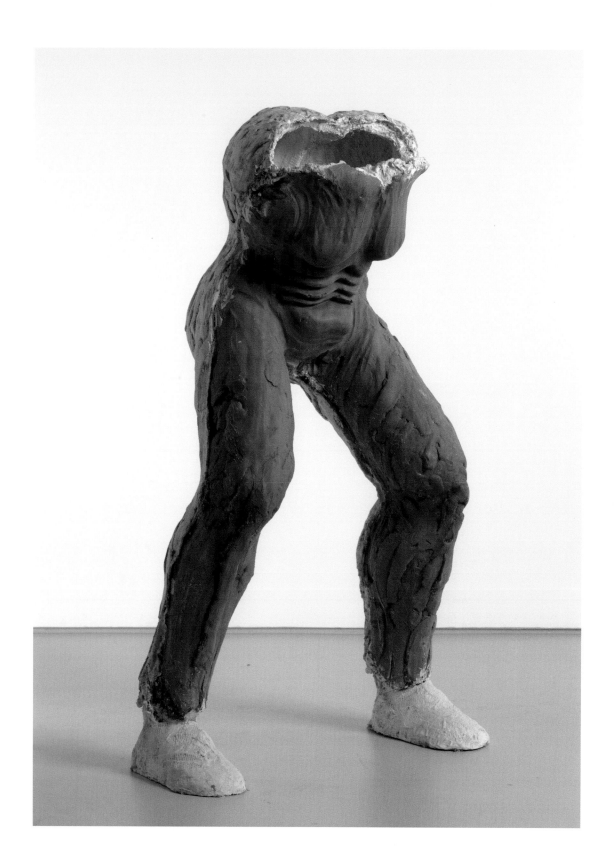

THOMAS HOUSEAGO

above:
Untitled 2000
Plaster, jute, iron rebar
190 x 110 x 75 cm

right:
Figure 2 2008
Wood, graphite, oil stick, tuf-cal,
hemp, iron rebar
228.6 x 83.8 x 134.6 cm

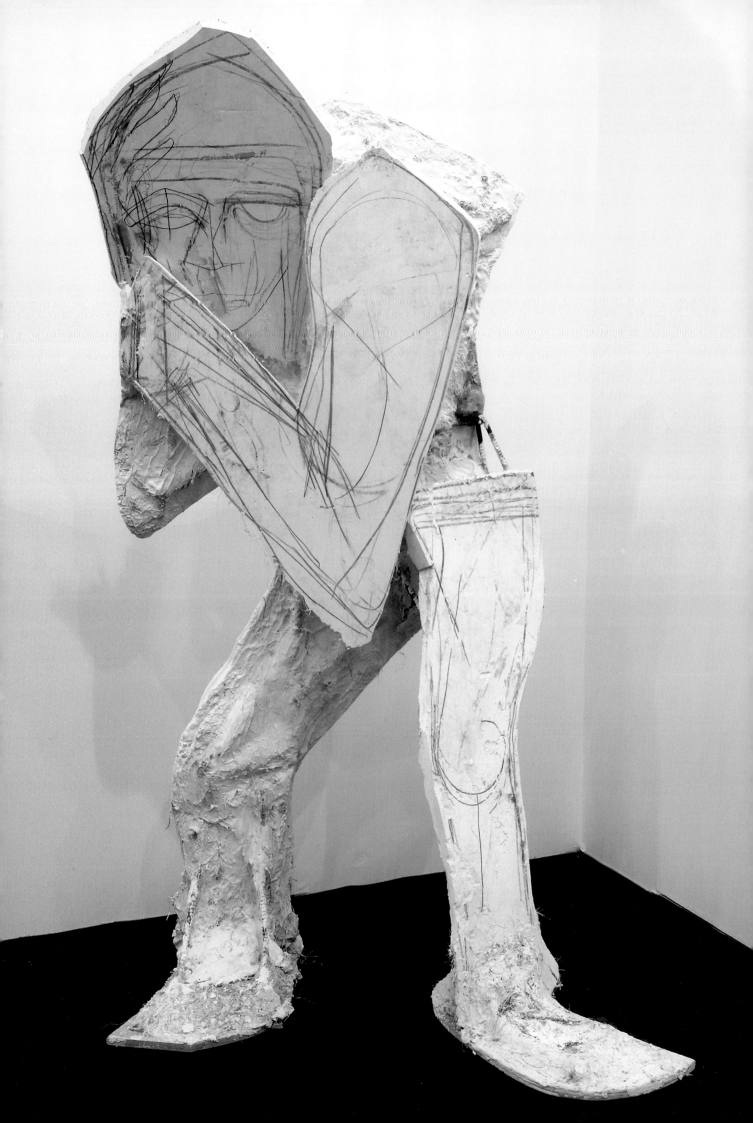

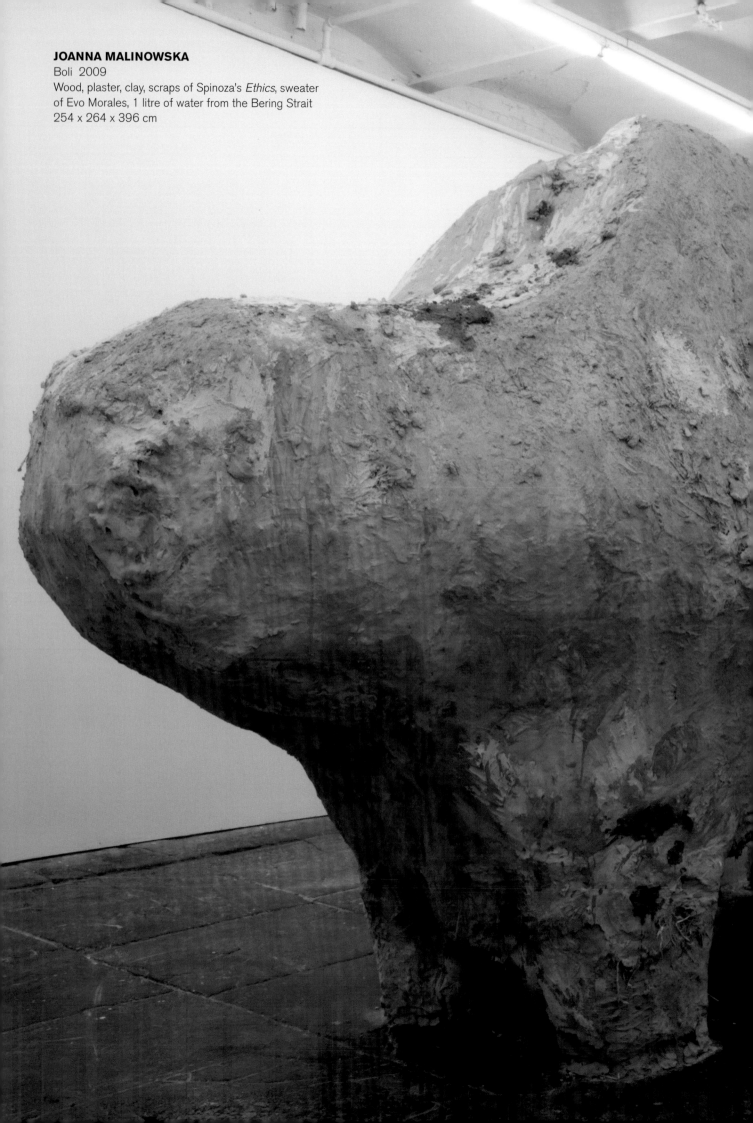

JOANNA MALINOWSKA
Boli 2009
Wood, plaster, clay, scraps of Spinoza's *Ethics*, sweater
of Evo Morales, 1 litre of water from the Bering Strait
254 x 264 x 396 cm

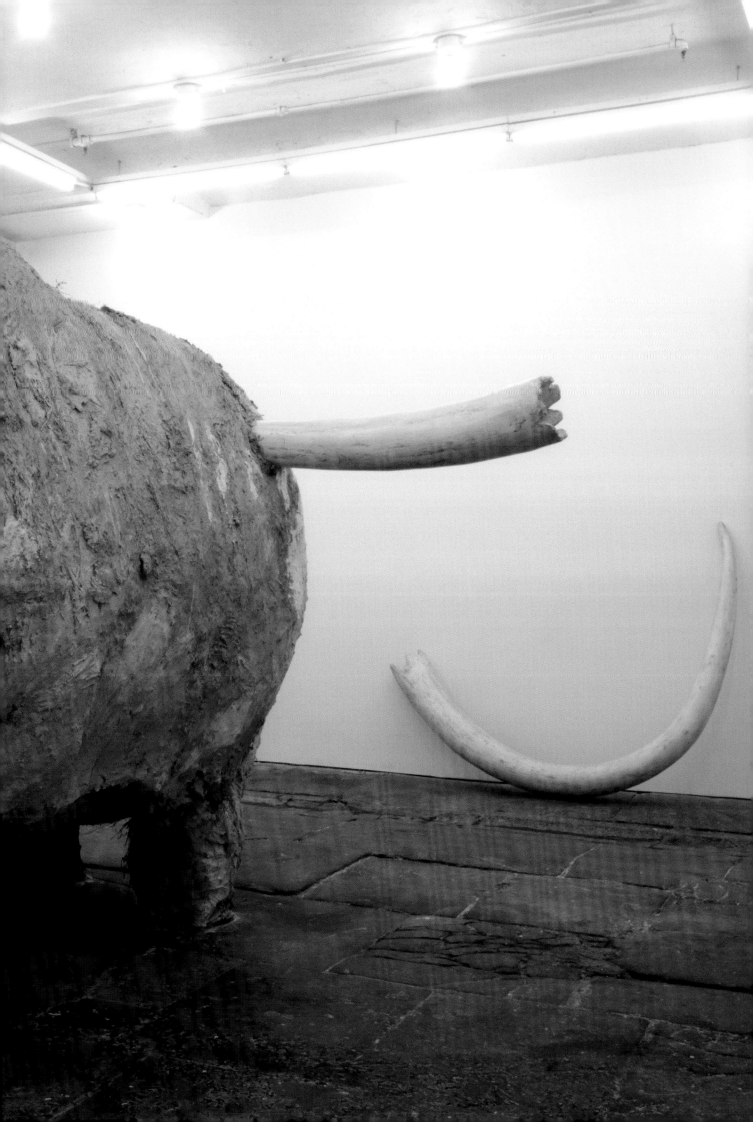

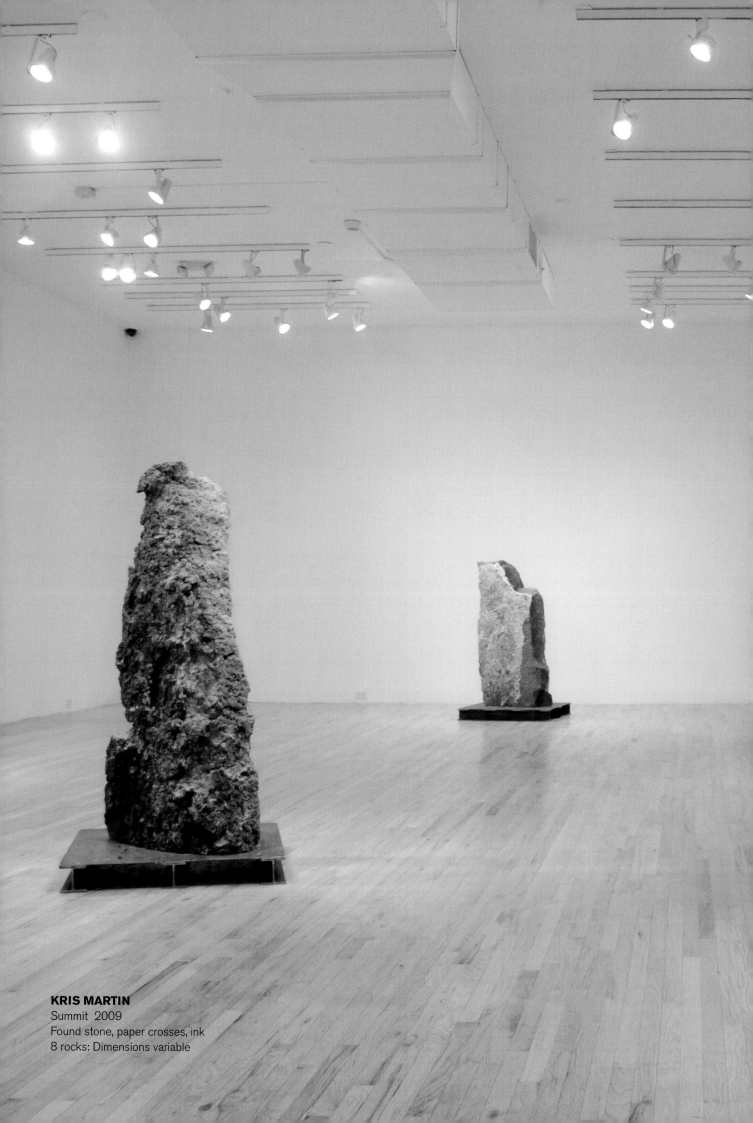

KRIS MARTIN
Summit 2009
Found stone, paper crosses, ink
8 rocks: Dimensions variable

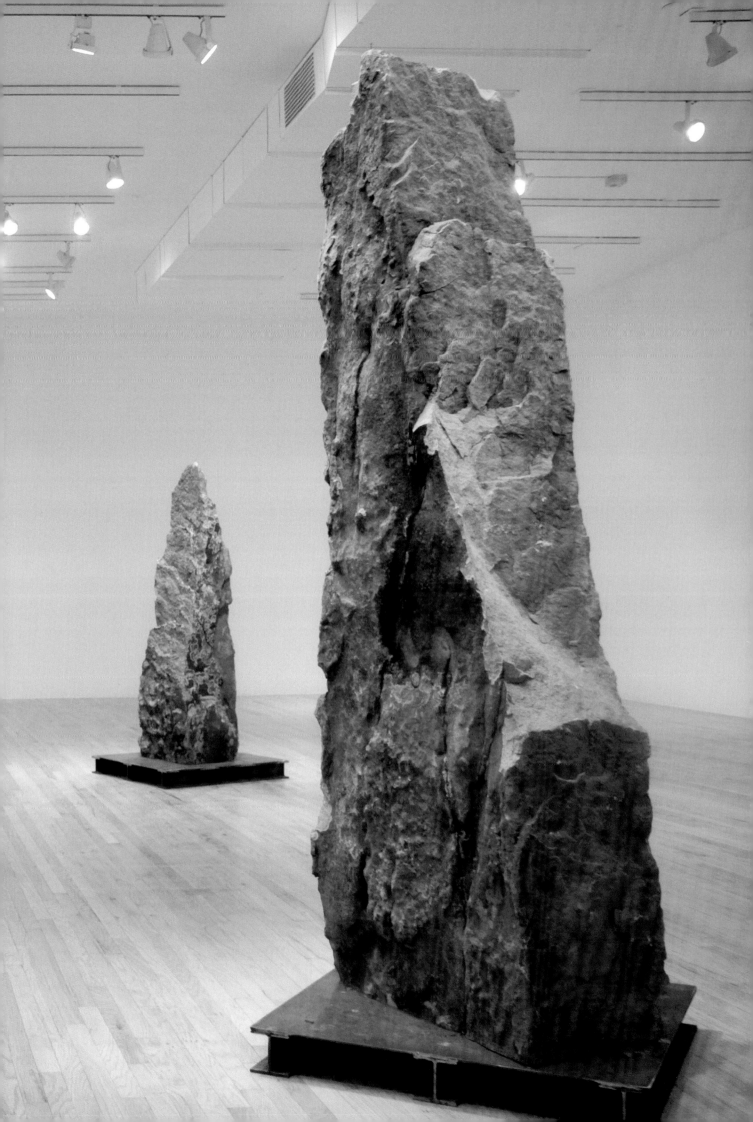

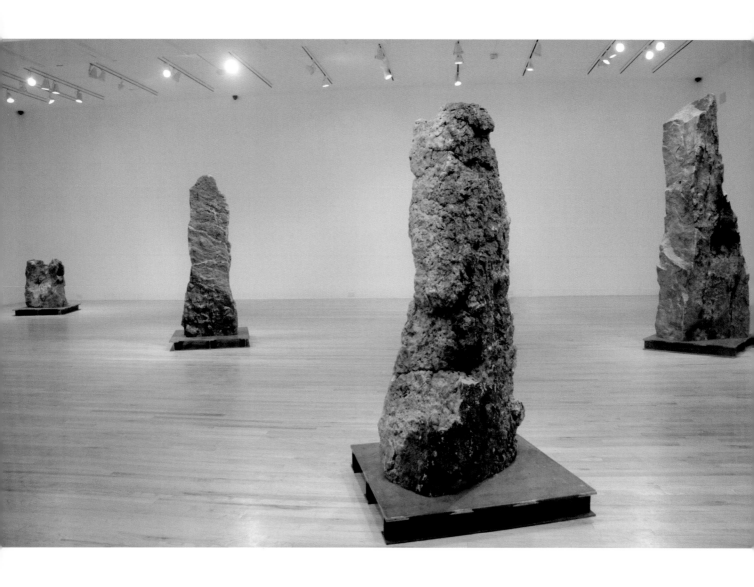

KRIS MARTIN
Summit 2009
Installation

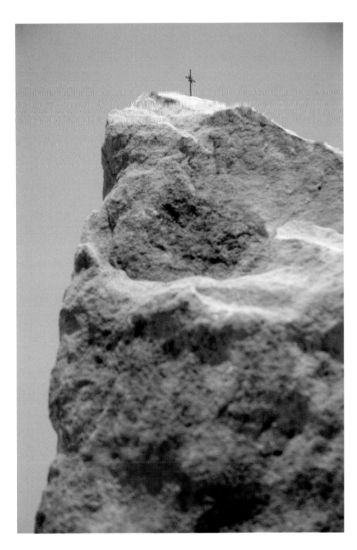

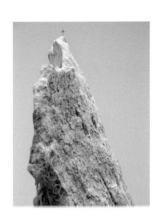

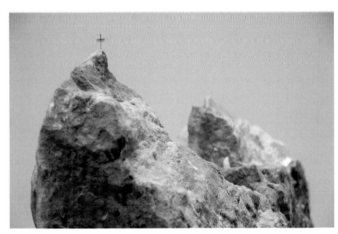

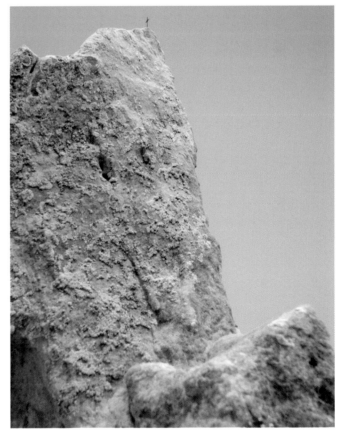

KRIS MARTIN
Summit 2009 (details)

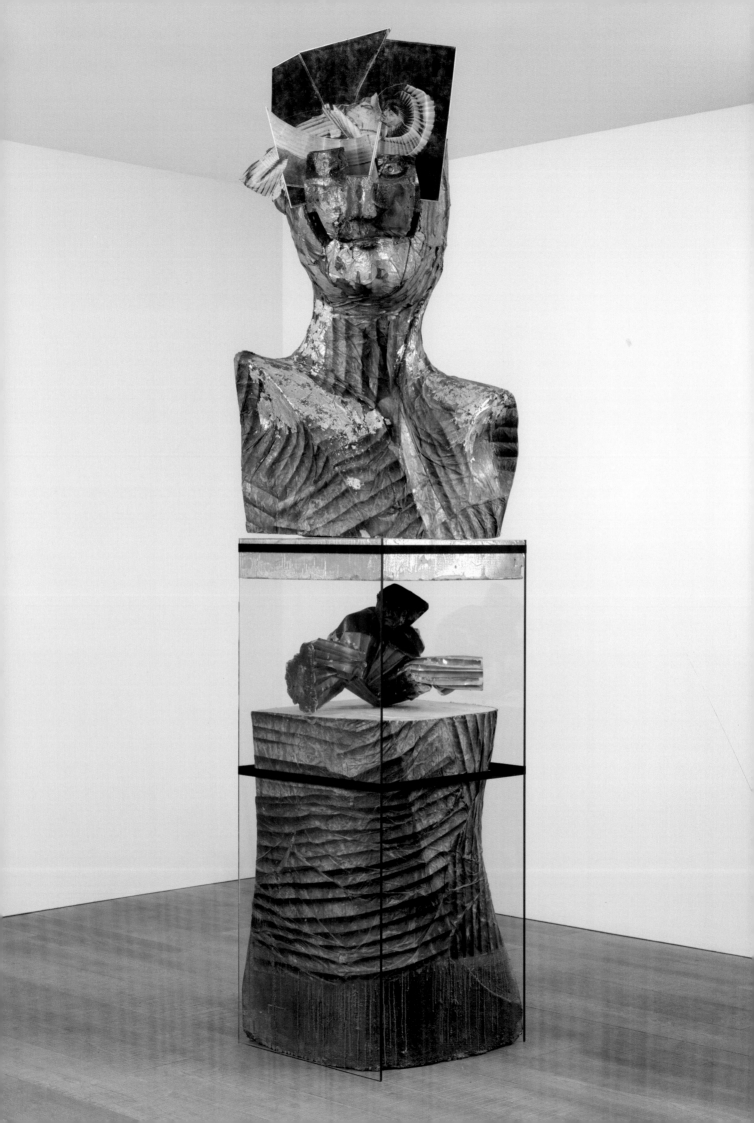

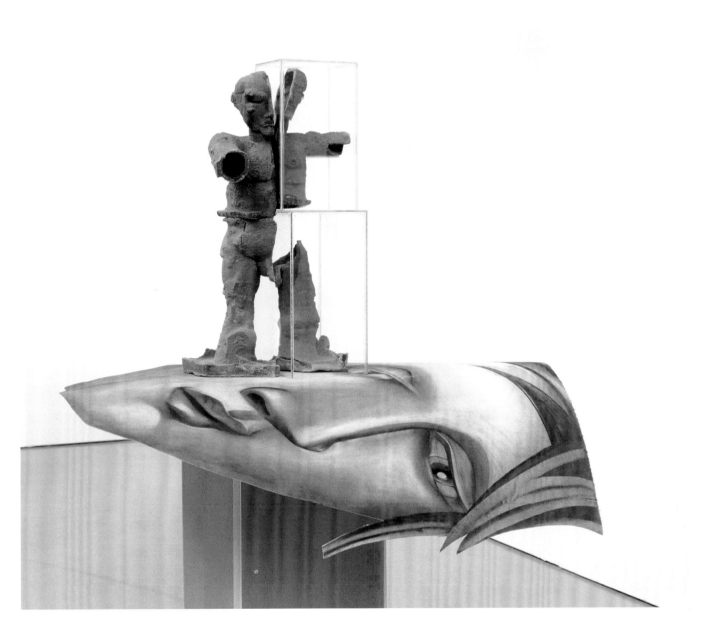

MATTHEW MONAHAN
above:
Sweet Grunt 2005
Mixed media
165 x 100 x 110 cm

left:
Midnight Mission 2009
Polyurethane foam, wax, epoxy resin, photocopy and charcoal on
paper, paint, pigment, metal leaf, glitter, glass, ratchet straps
295 x 61 x 63.5 cm

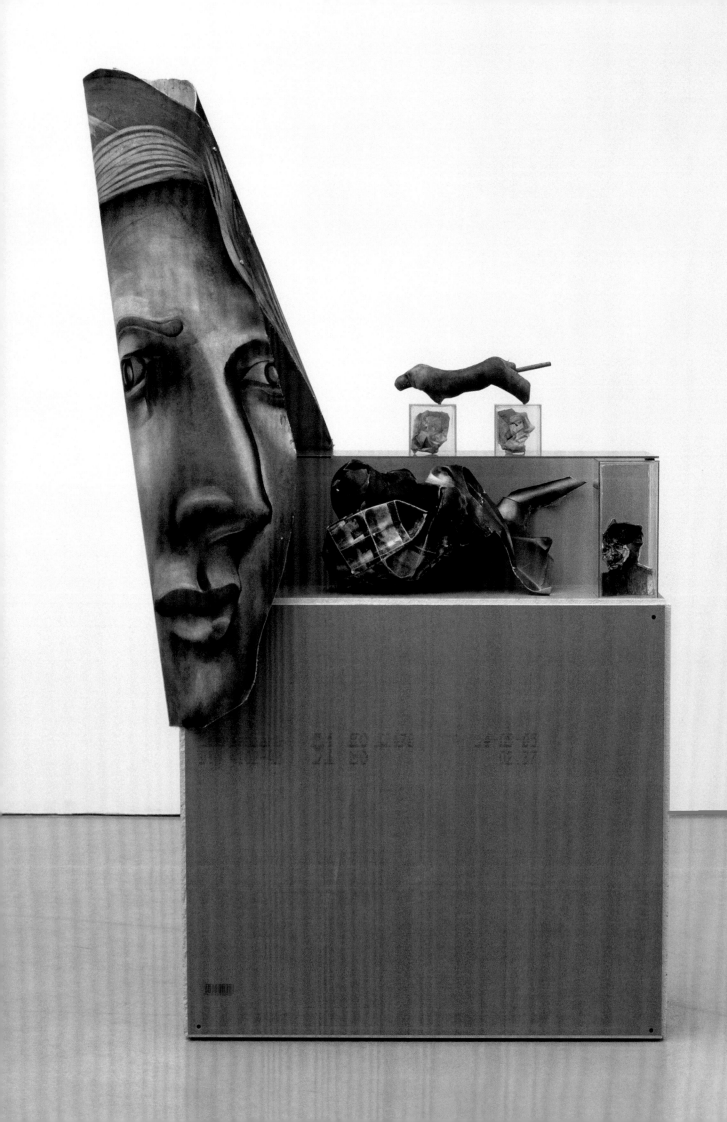

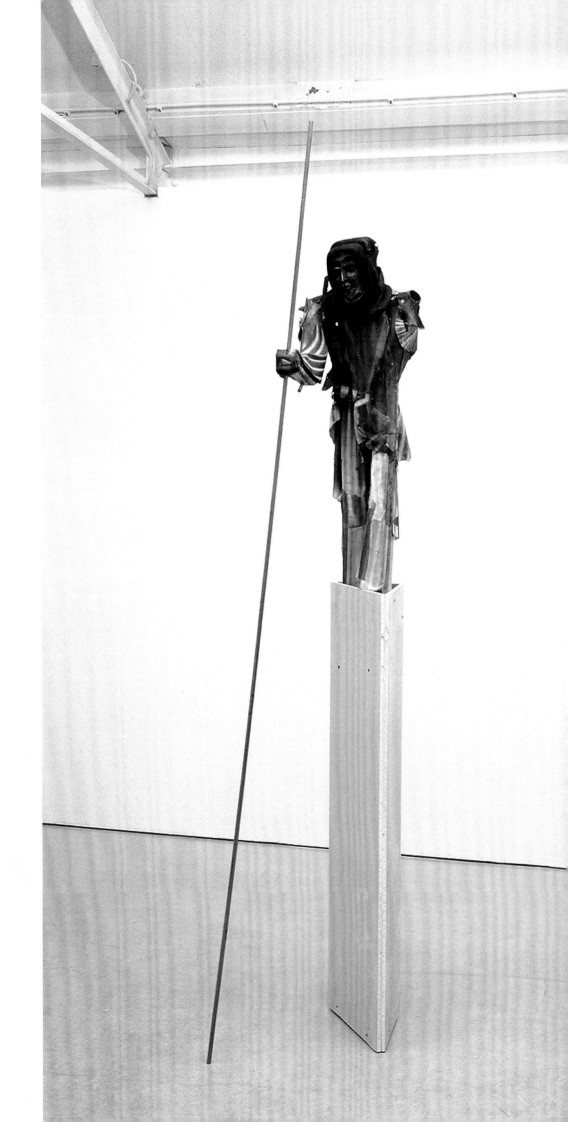

MATTHEW MONAHAN
right:
Blindness Is Believing 2005
Mixed media
250 x 50 x 37 cm

left:
Riker's Island 2005
Mixed media
205 x 110 x 45 cm

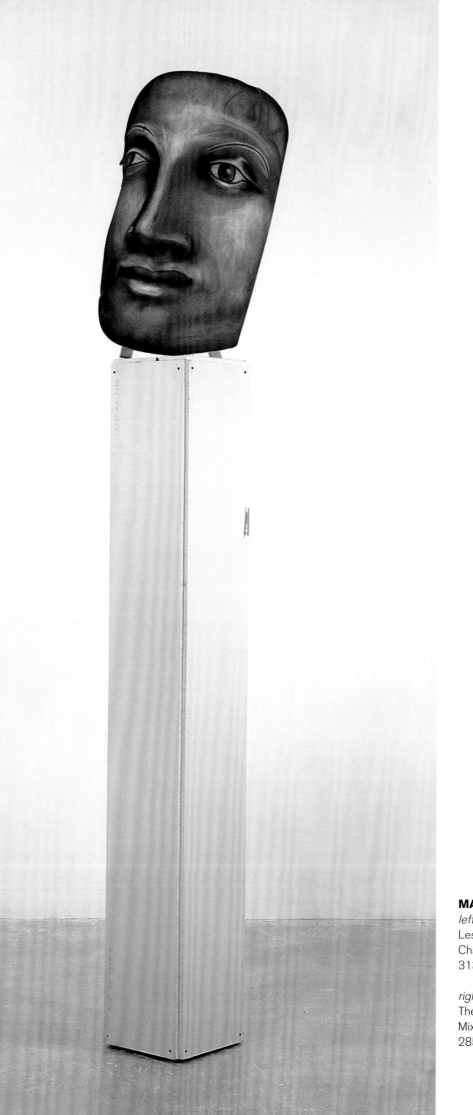

MATTHEW MONAHAN
left:
Lesser Known Son 1994
Charcoal on paper, wood, dry wall
313 x 66 x 41 cm

right:
The Family Tree 2005
Mixed media
285 x 82 x 63 cm

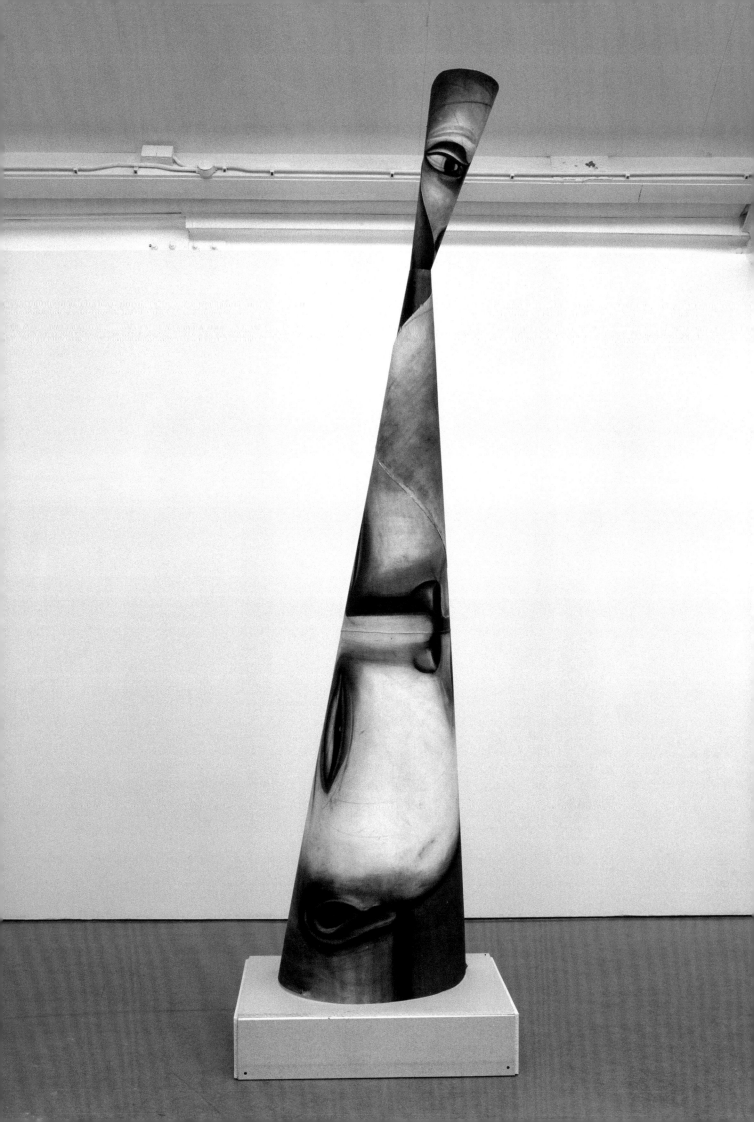

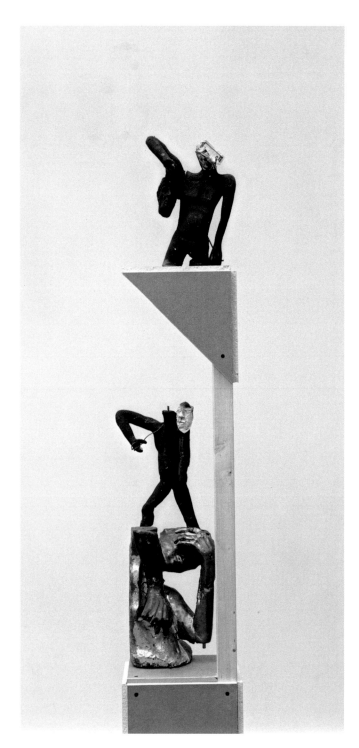

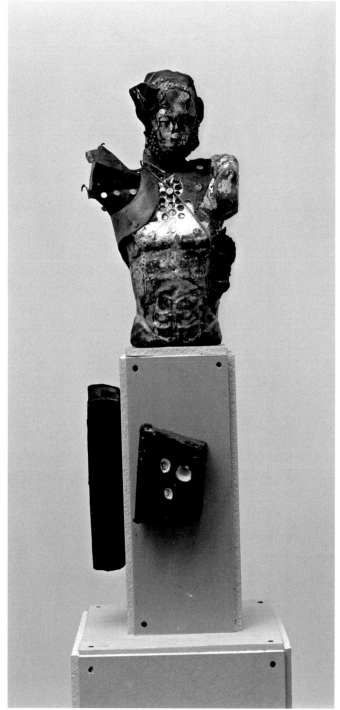

MATTHEW MONAHAN
above:
The Benjamins 2005
Mixed media
215 x 27 x 27 cm

above right:
Tarted Up For The Lions 2005
Mixed media
188 x 32 x 32 cm

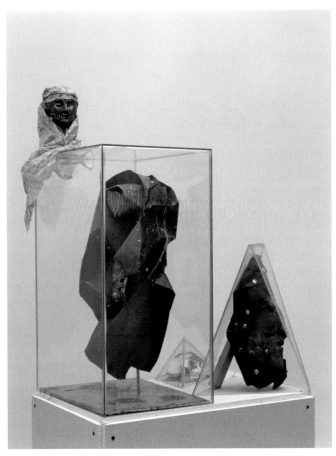

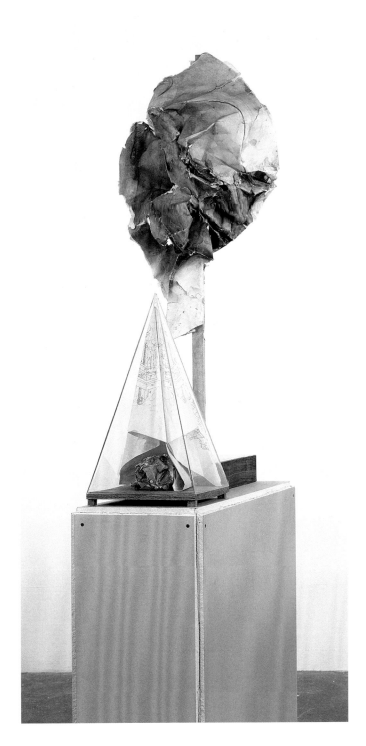

MATTHEW MONAHAN
above:
Guild Of Mad Builders 1994
Charcoal on paper on muslin,
wood, wax glass, carbon paper,
transfer drawing, dry wall
246 x 94 x 51 cm

above right:
Blood For Oil 2005
Mixed media
160 x 62 x 62 cm

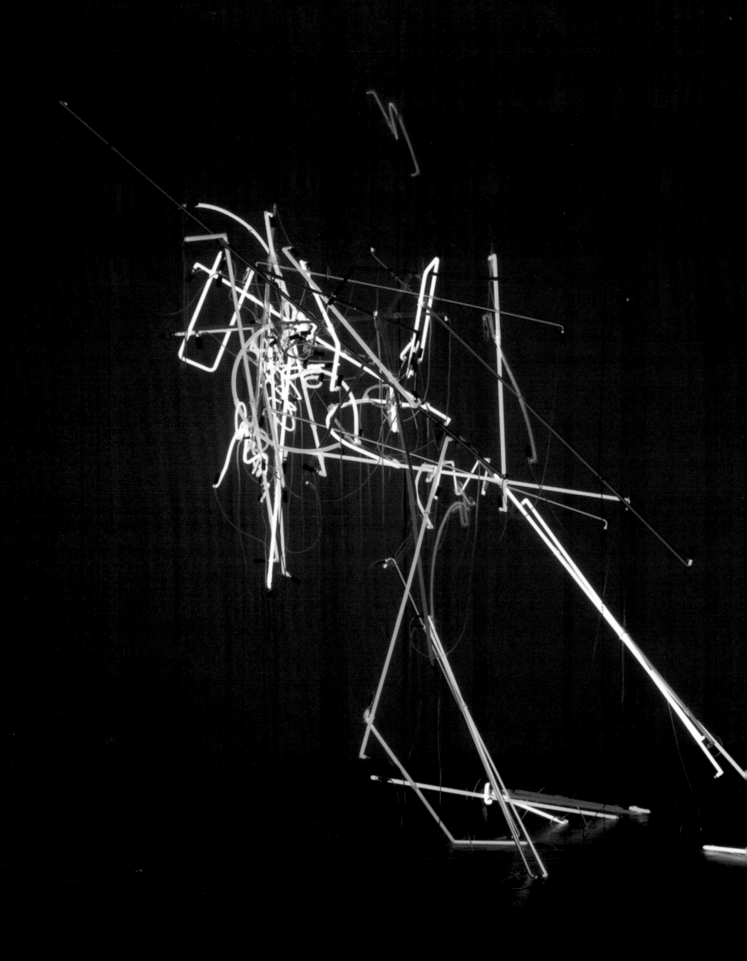

ANSELM REYLE
Untitled 2006
119 neon tubes, chains, cable and 13 transformators
5 x 10 x 8 m

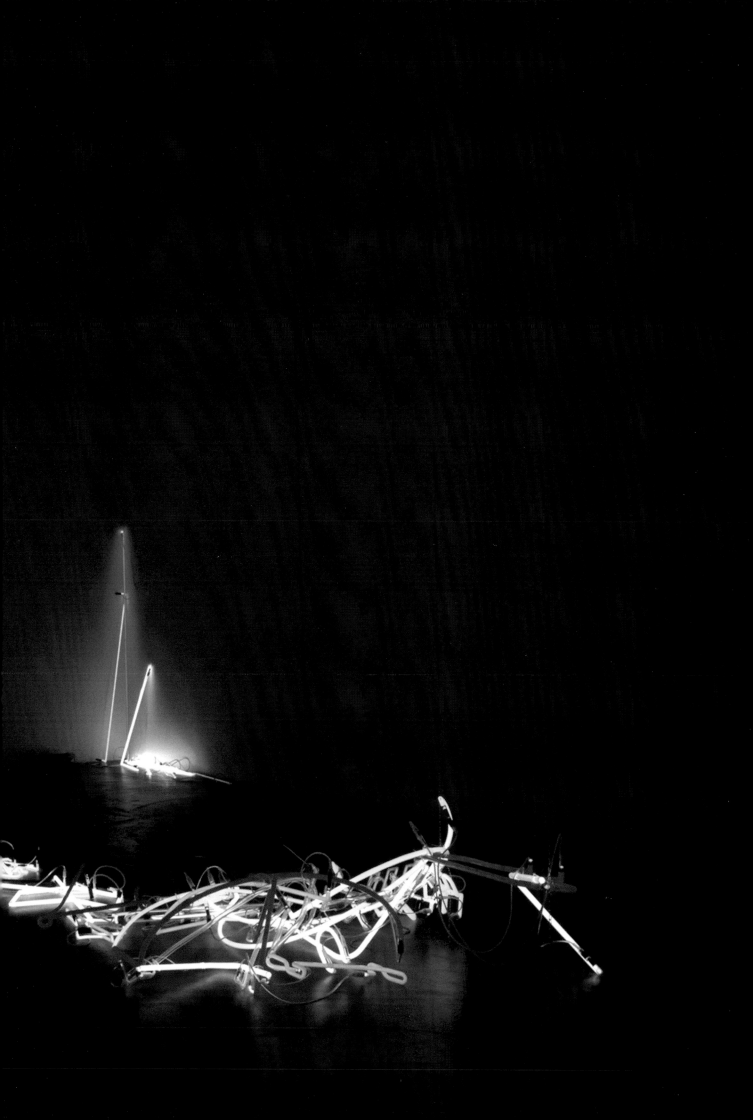

ANSELM REYLE
Untitled 2005
Bronze, chrome, varnish
242.5 x 120 x 120 cm

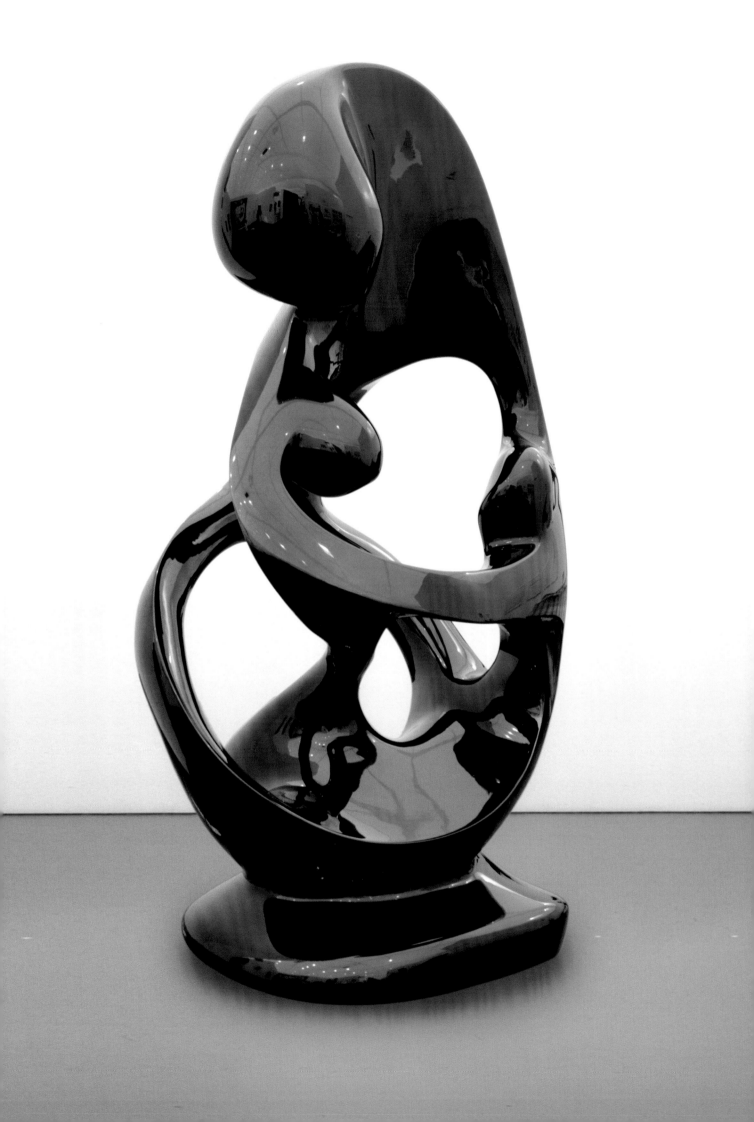

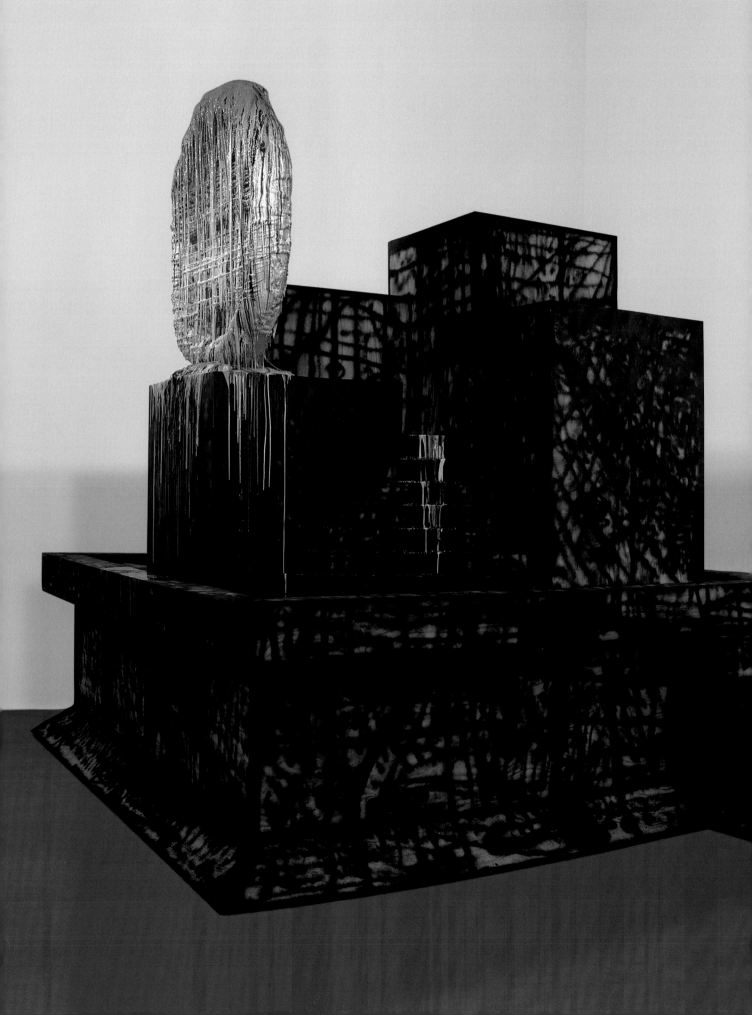

STERLING RUBY
Recondite 2007
PVC pipe, plastic urethane, wood, aluminium, spray paint
Overall dimensions: 464.8 x 853.4 x 426.7 cm

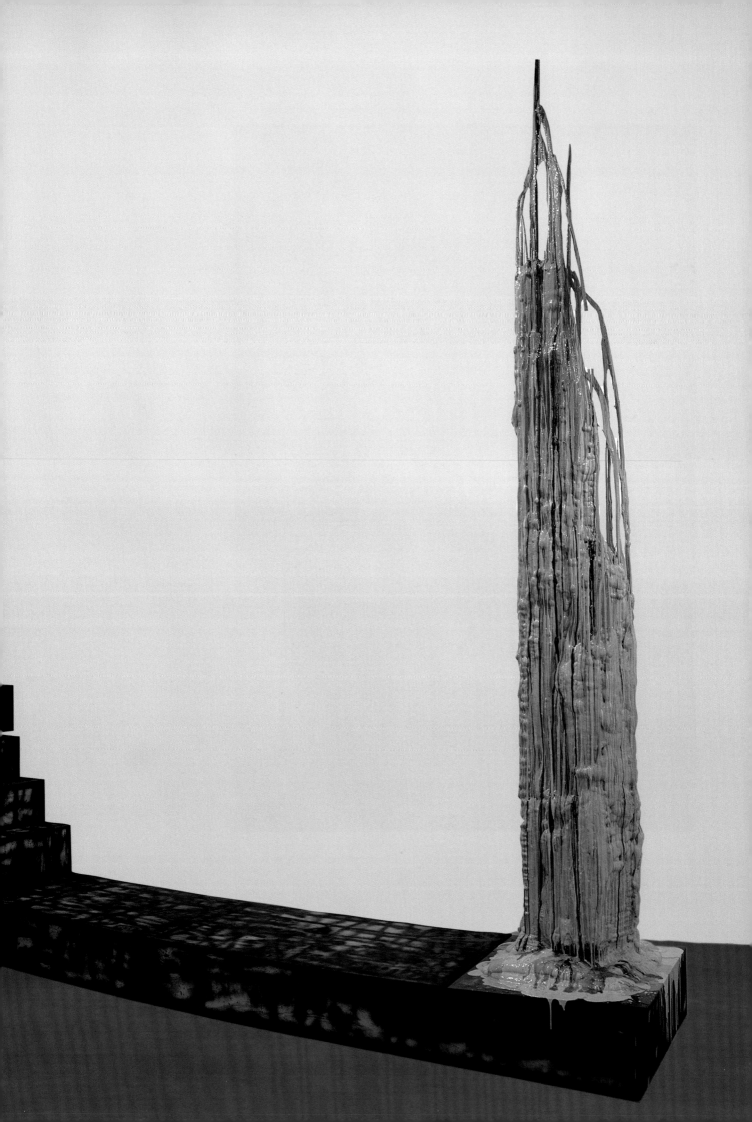

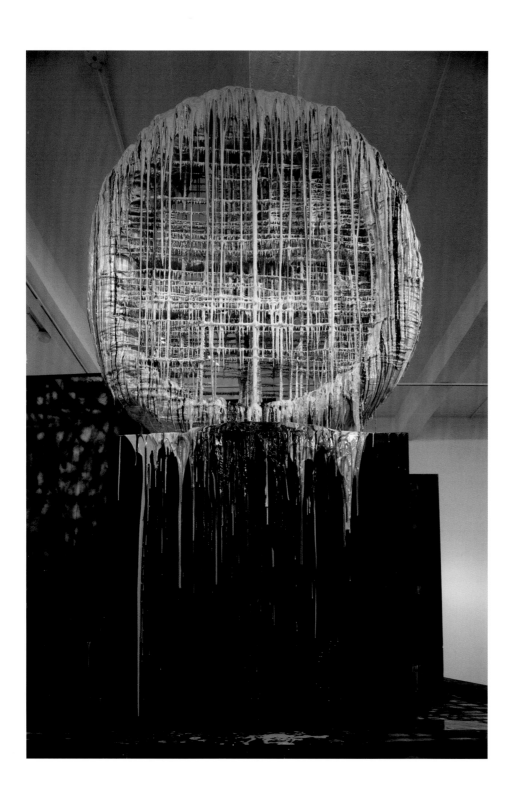

STERLING RUBY
Recondite 2007 (details)

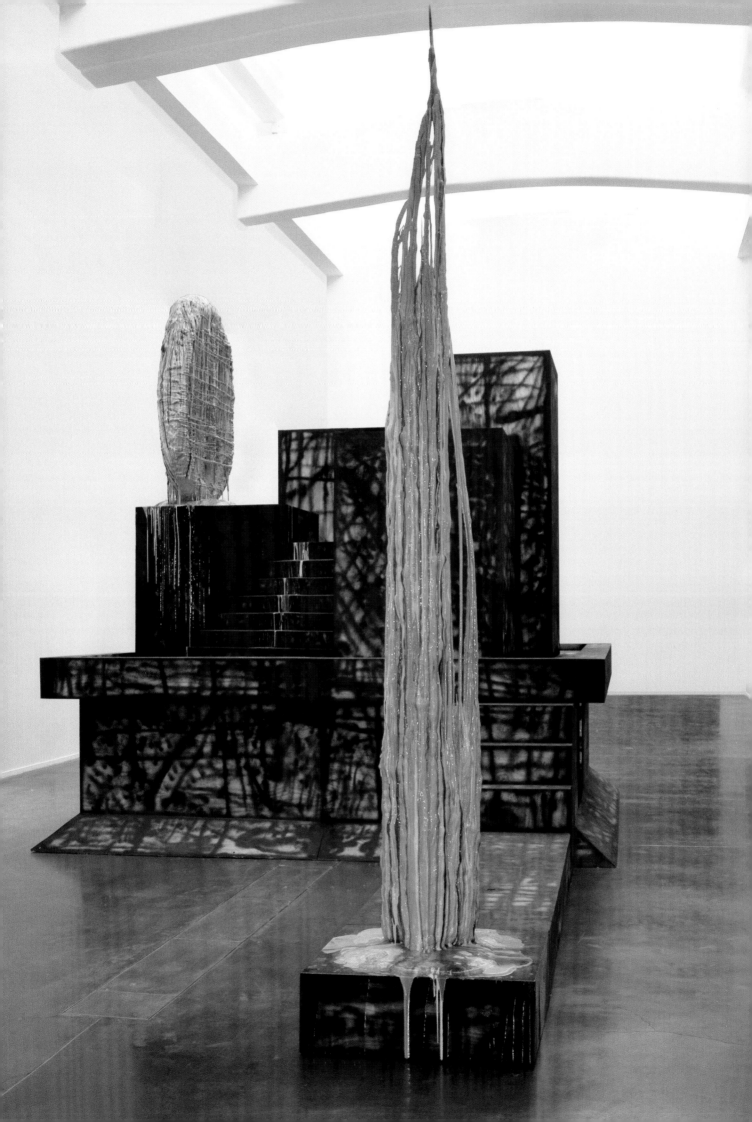

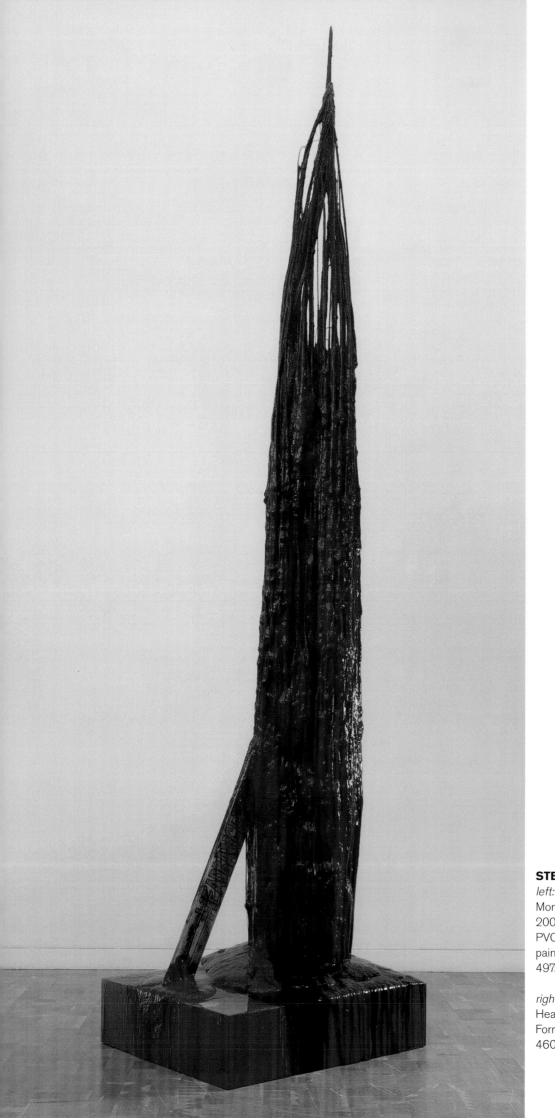

STERLING RUBY
left:
Monument Stalagmite/Headbanger
2008
PVC pipe, formica, urethane, spray
paint and wood
497.8 x 101 x 122 cm

right:
Headless Dick/Deth Till 2008
Formica, wood, glue, spray paint, nails
460 x 122 x 381 cm

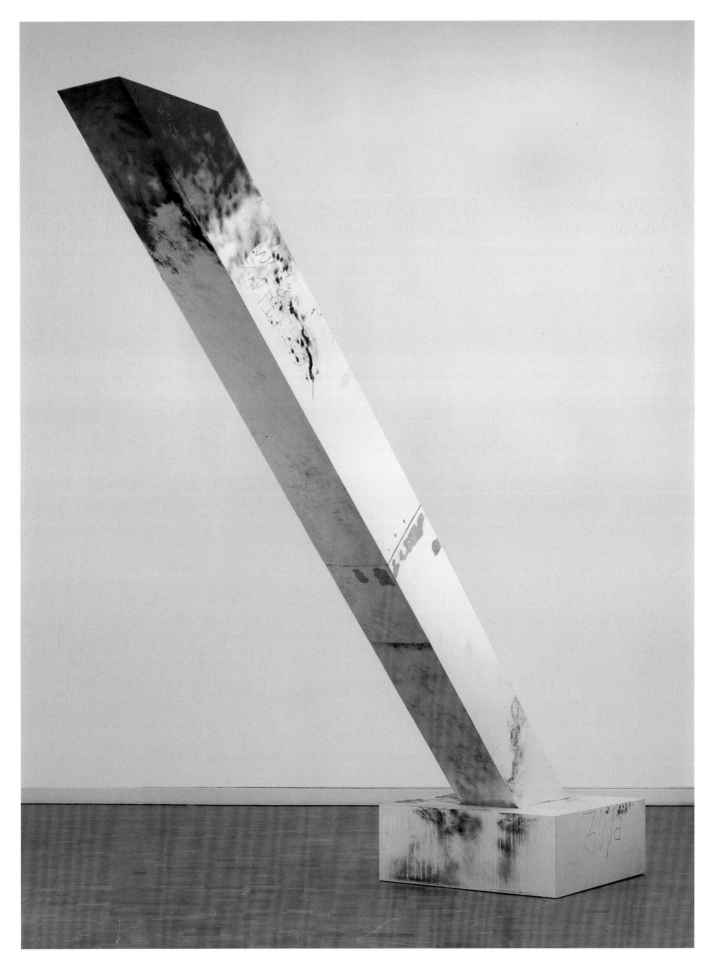

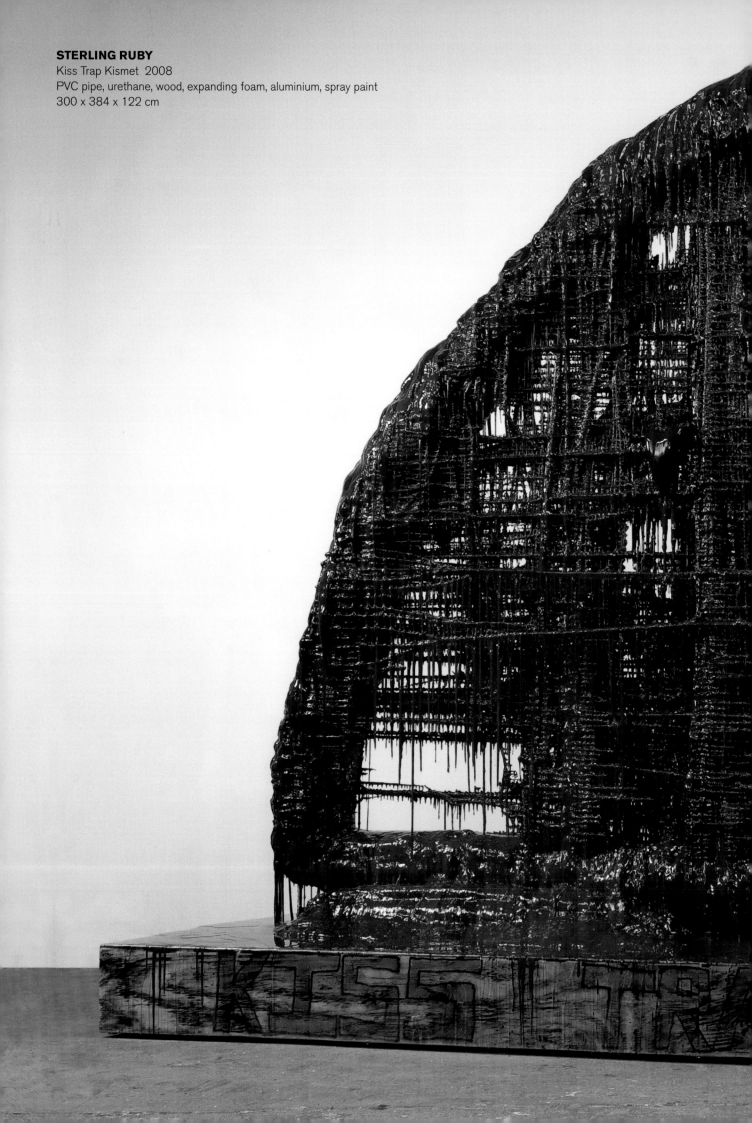

STERLING RUBY
Kiss Trap Kismet 2008
PVC pipe, urethane, wood, expanding foam, aluminium, spray paint
300 x 384 x 122 cm

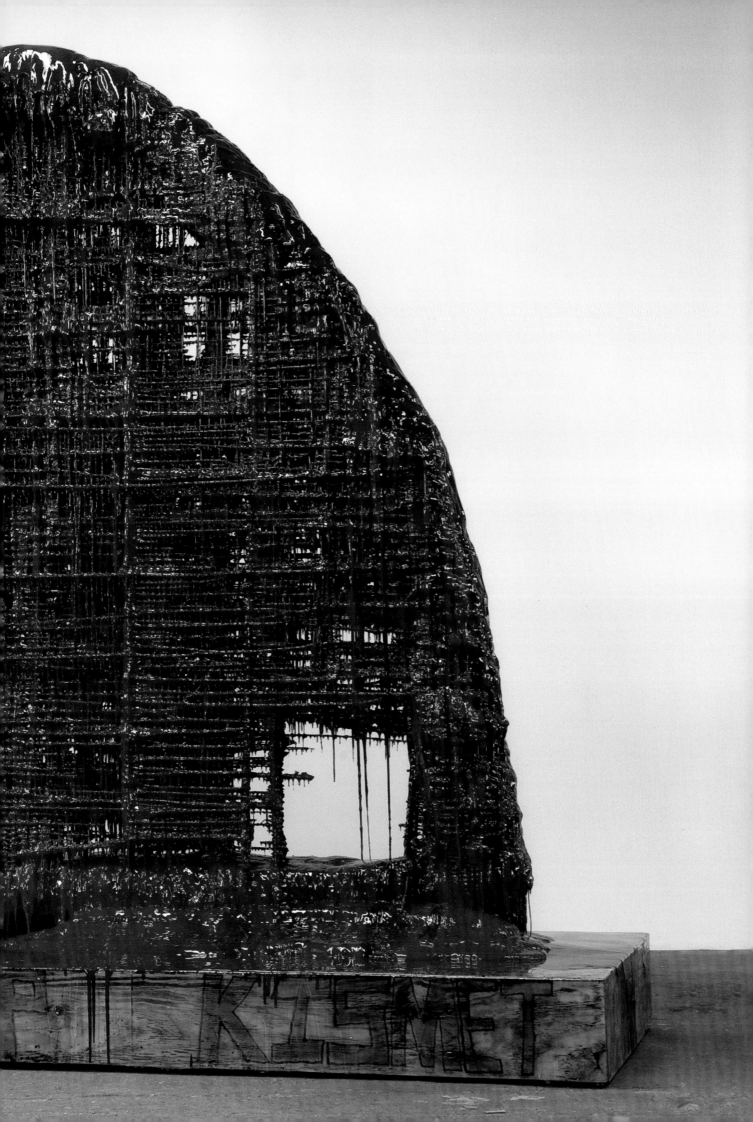

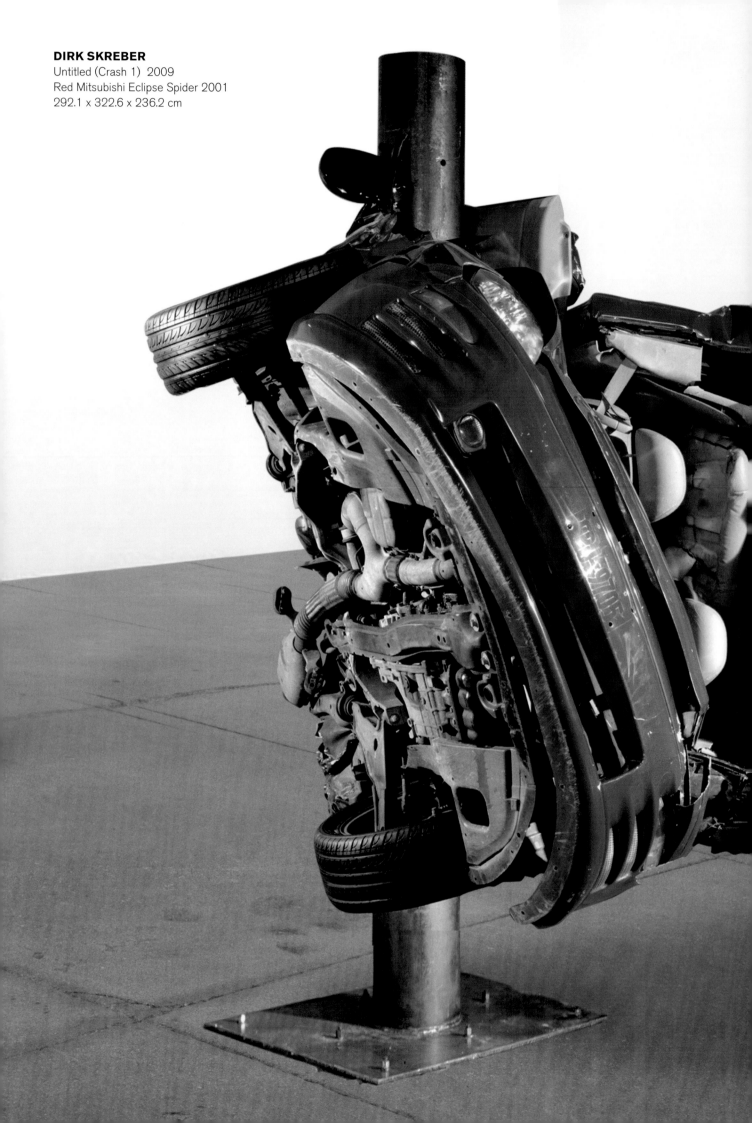

DIRK SKREBER
Untitled (Crash 1) 2009
Red Mitsubishi Eclipse Spider 2001
292.1 x 322.6 x 236.2 cm

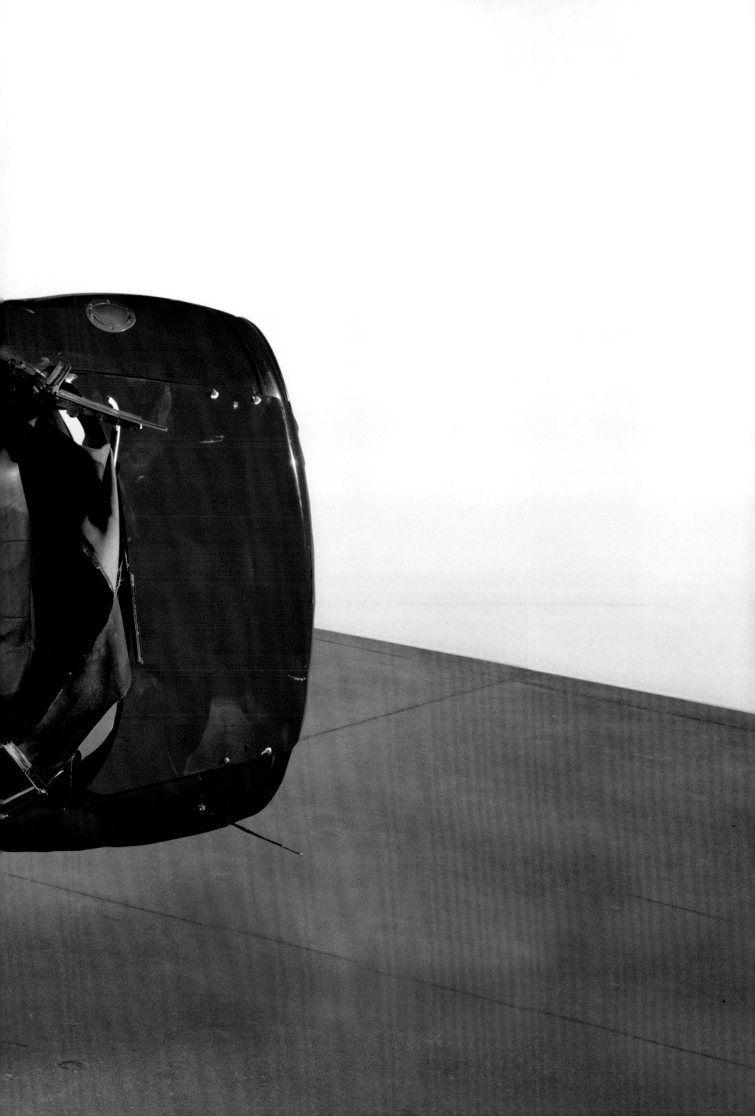

DIRK SKREBER
Untitled (Crash 2) 2009
Black Hyundai Tiburon 2001
231.1 x 315 x 259.1 cm

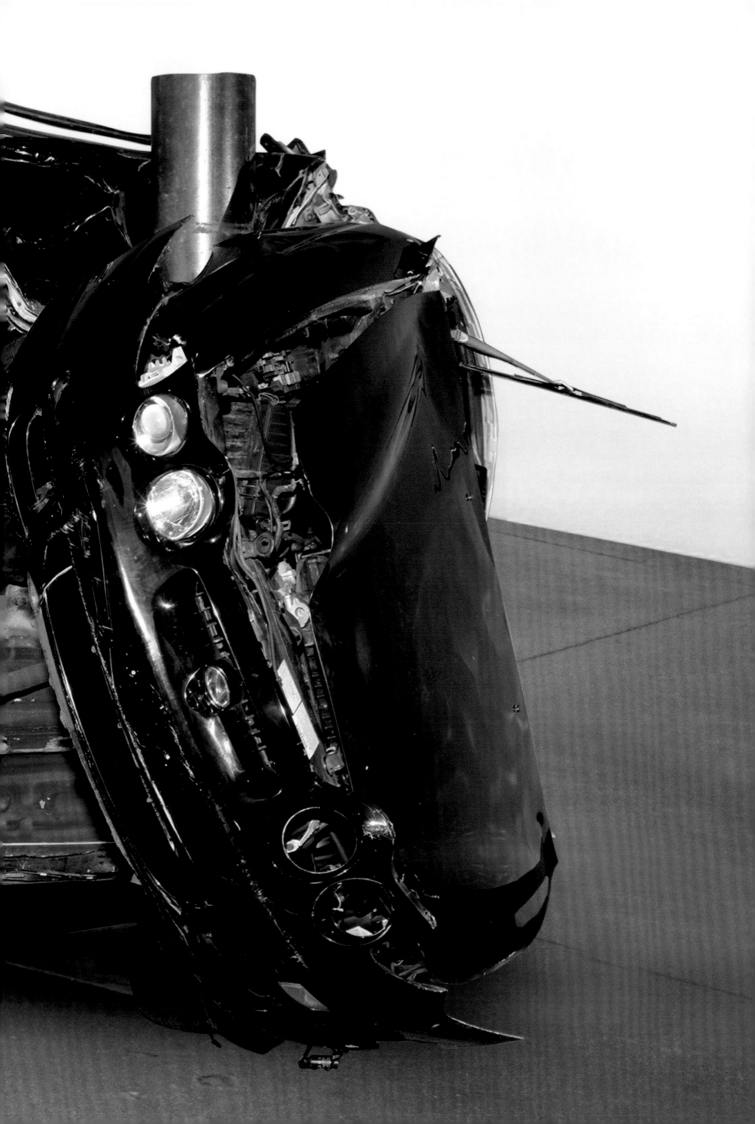

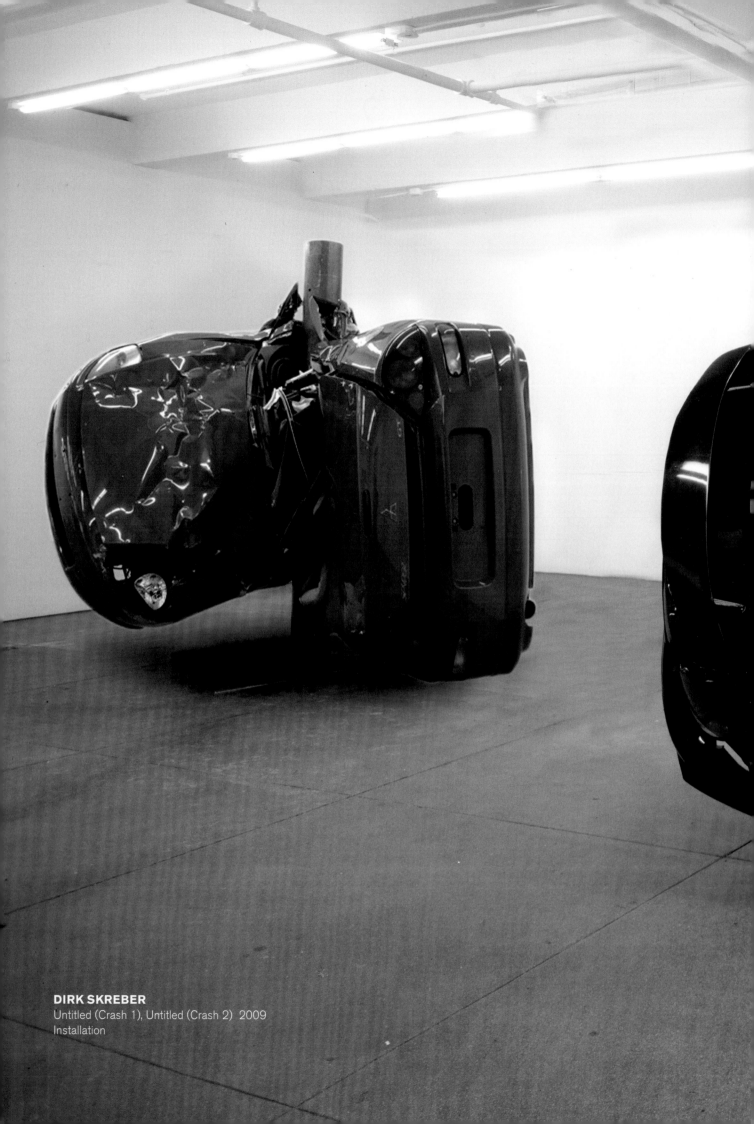

DIRK SKREBER
Untitled (Crash 1), Untitled (Crash 2) 2009
Installation

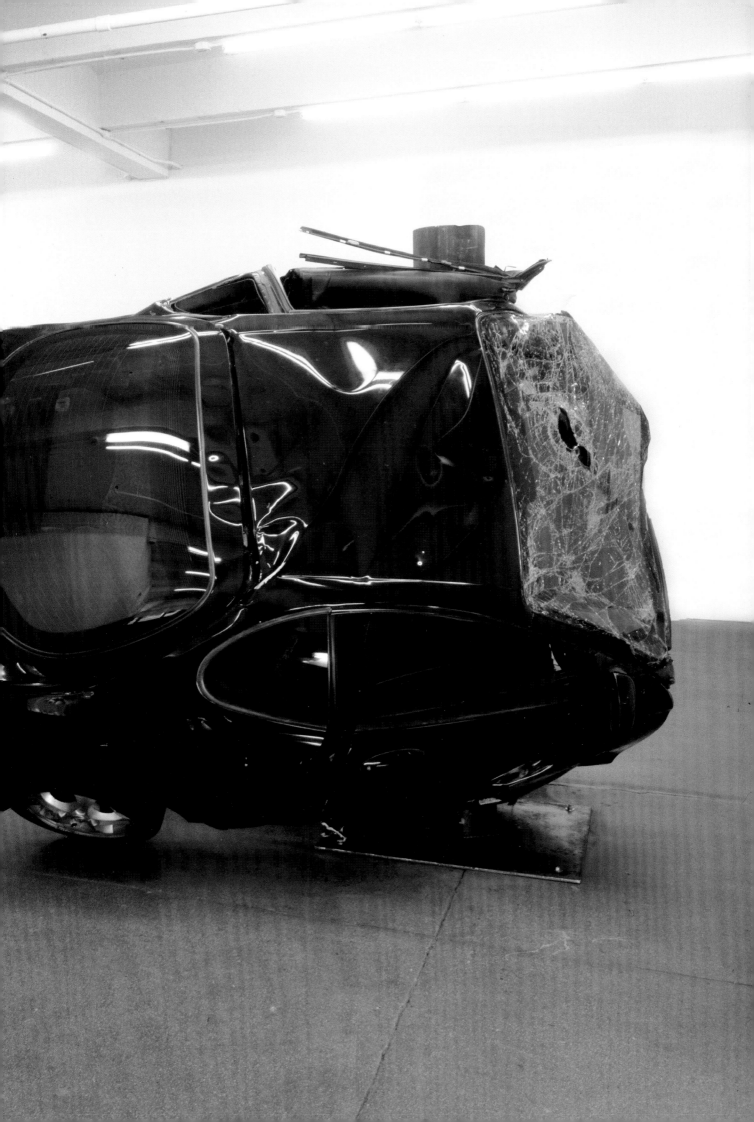

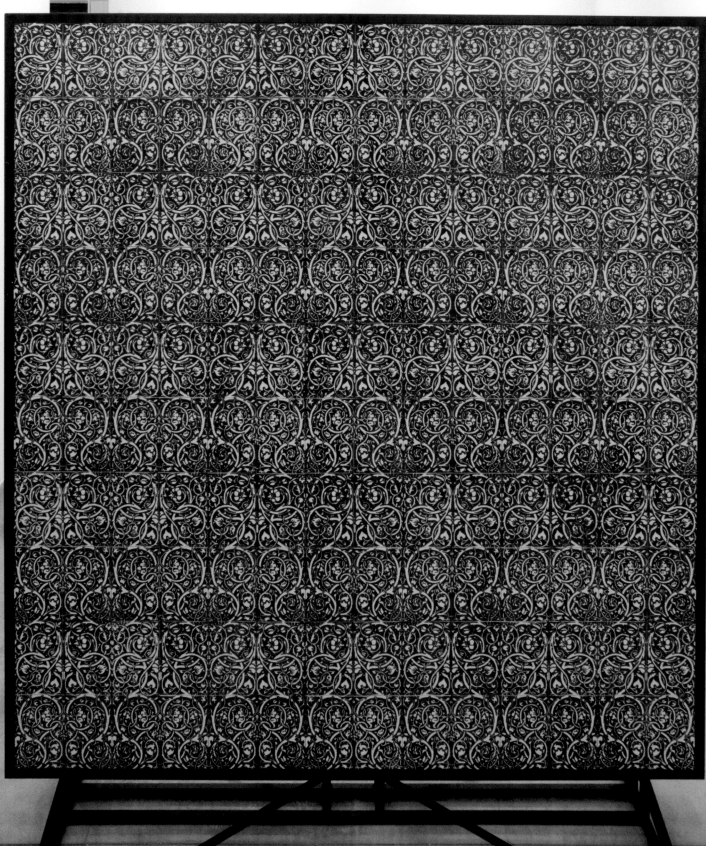

DAVID THORPE
Endeavours 2010
Wood, ceramic tiles, steel
309.2 x 262.3 x 120 cm

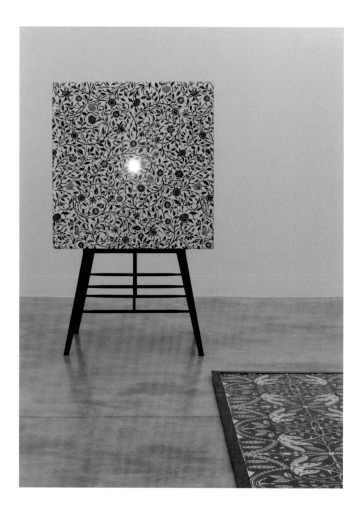

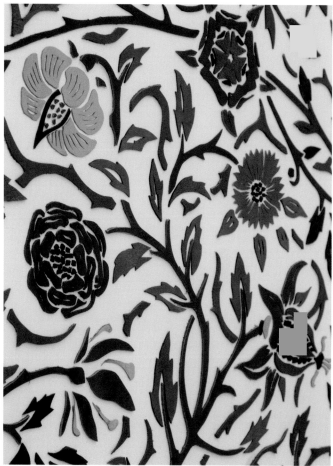

DAVID THORPE
Private Lives 2010
Plaster, leather, light system, wood stand
107.3 x 106 x 106 cm, Wood stand: 70.5 x 93.3 x 93.3 cm

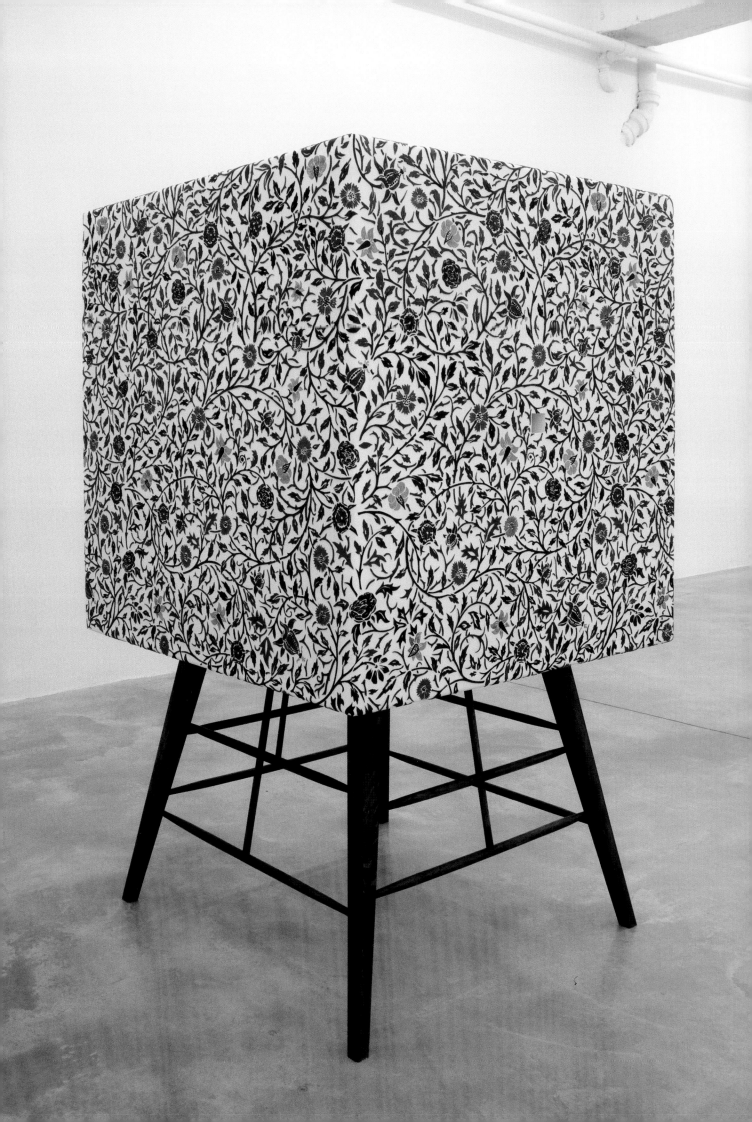

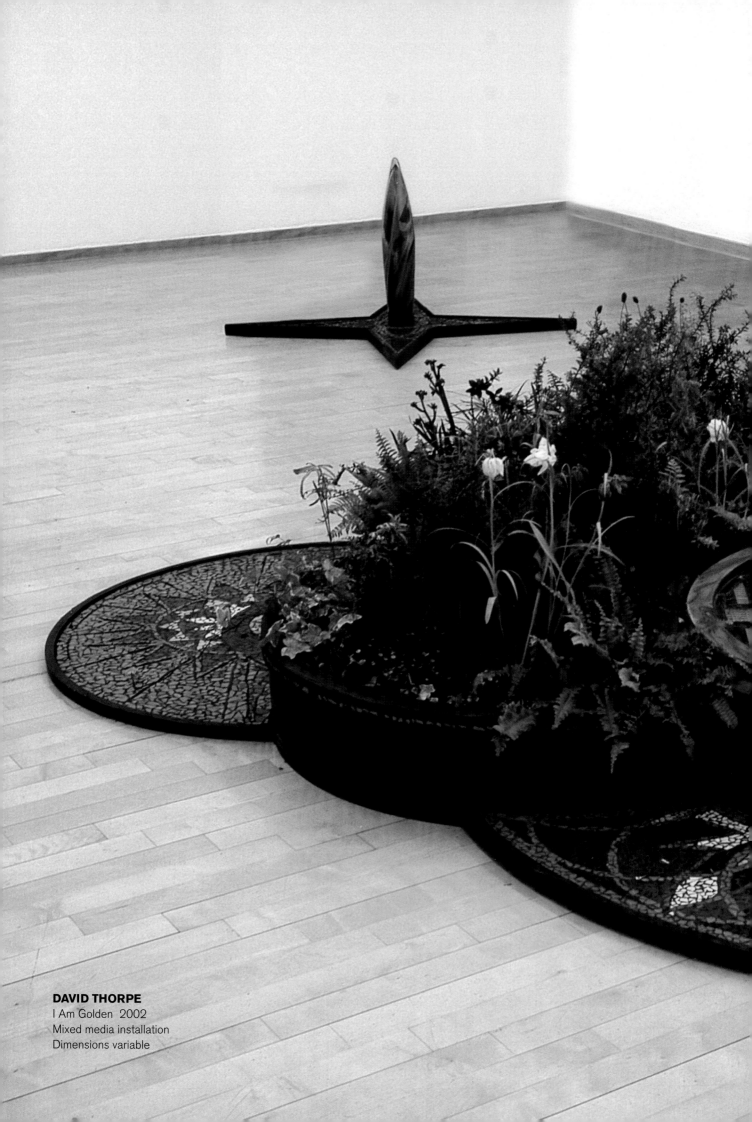

DAVID THORPE
I Am Golden 2002
Mixed media installation
Dimensions variable

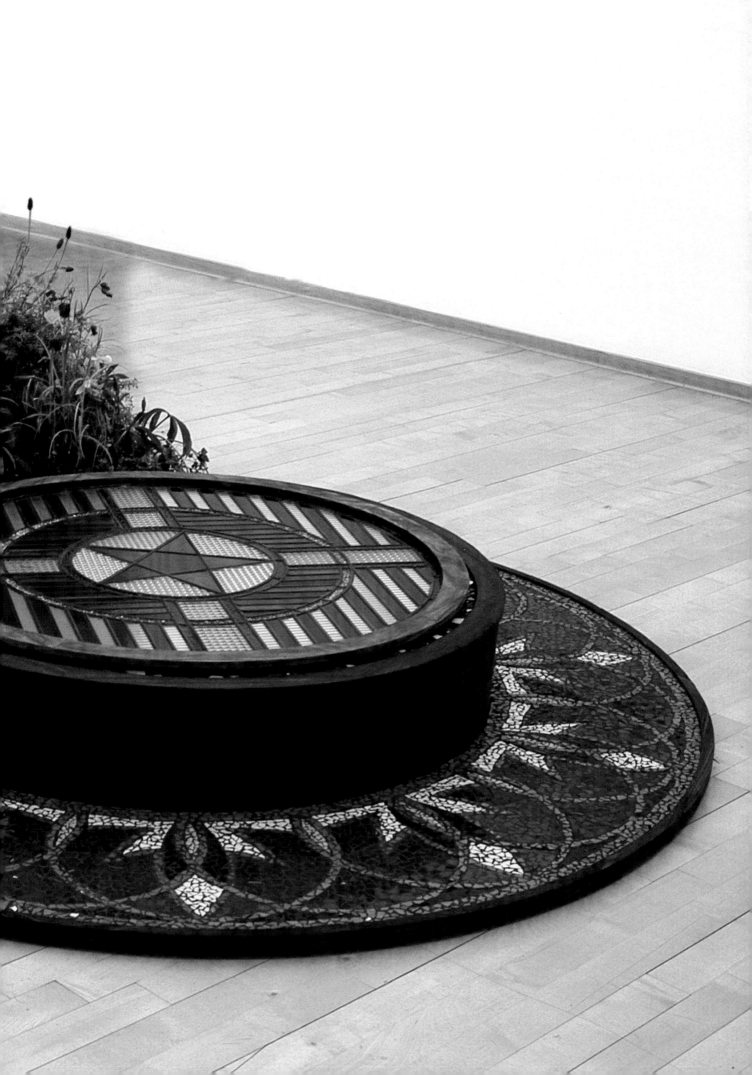

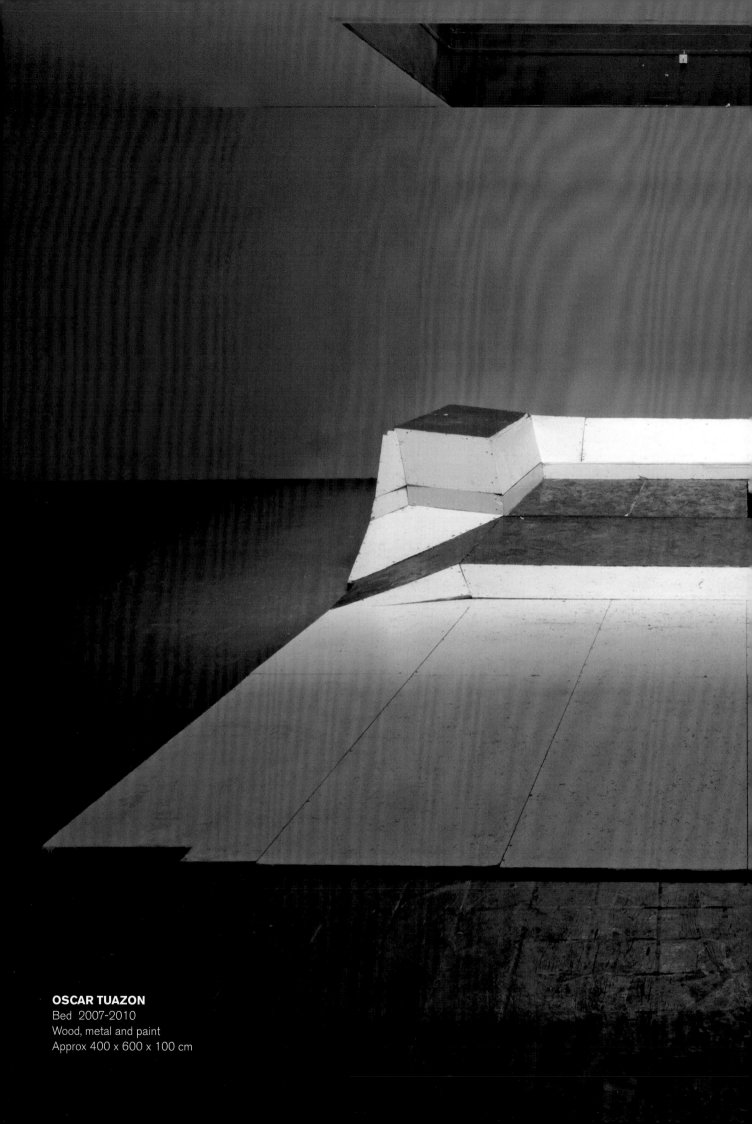

OSCAR TUAZON
Bed 2007-2010
Wood, metal and paint
Approx 400 x 600 x 100 cm

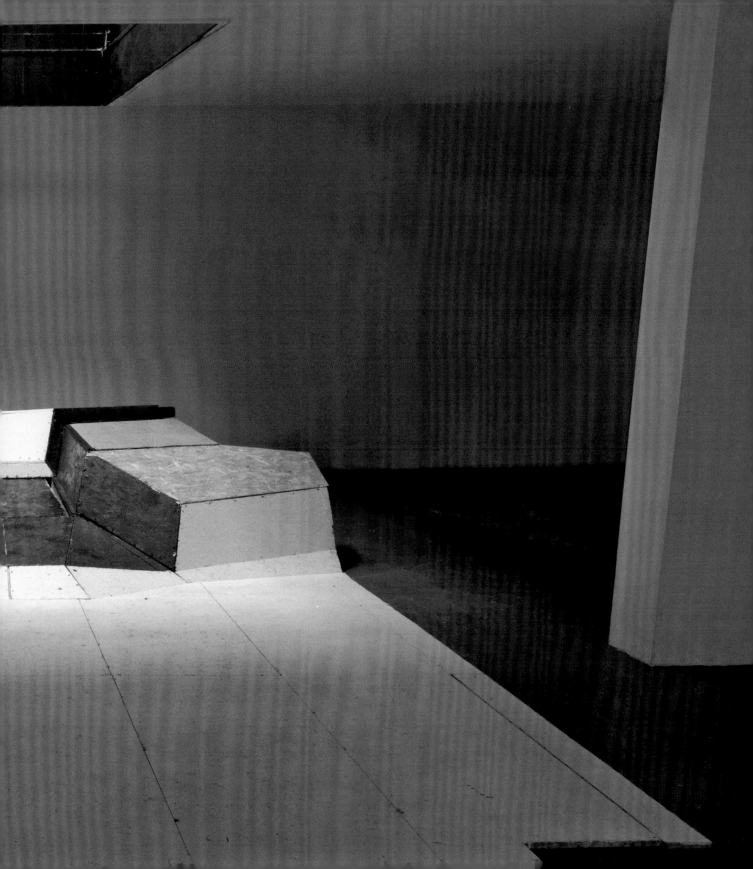

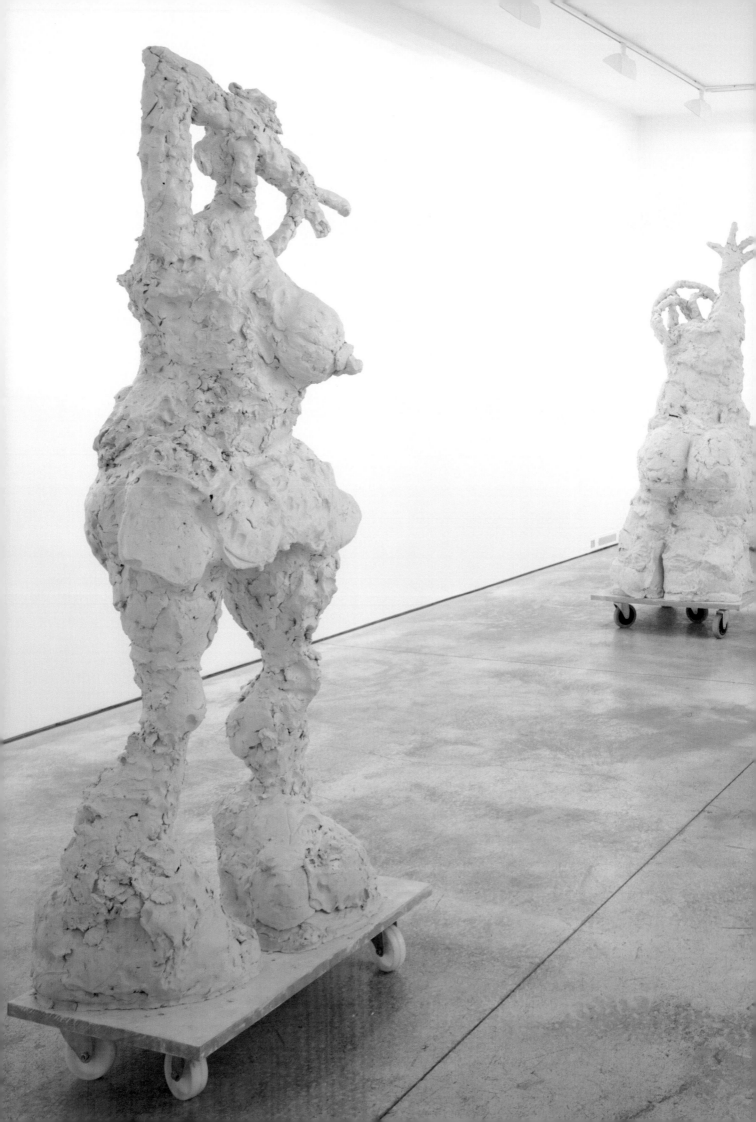

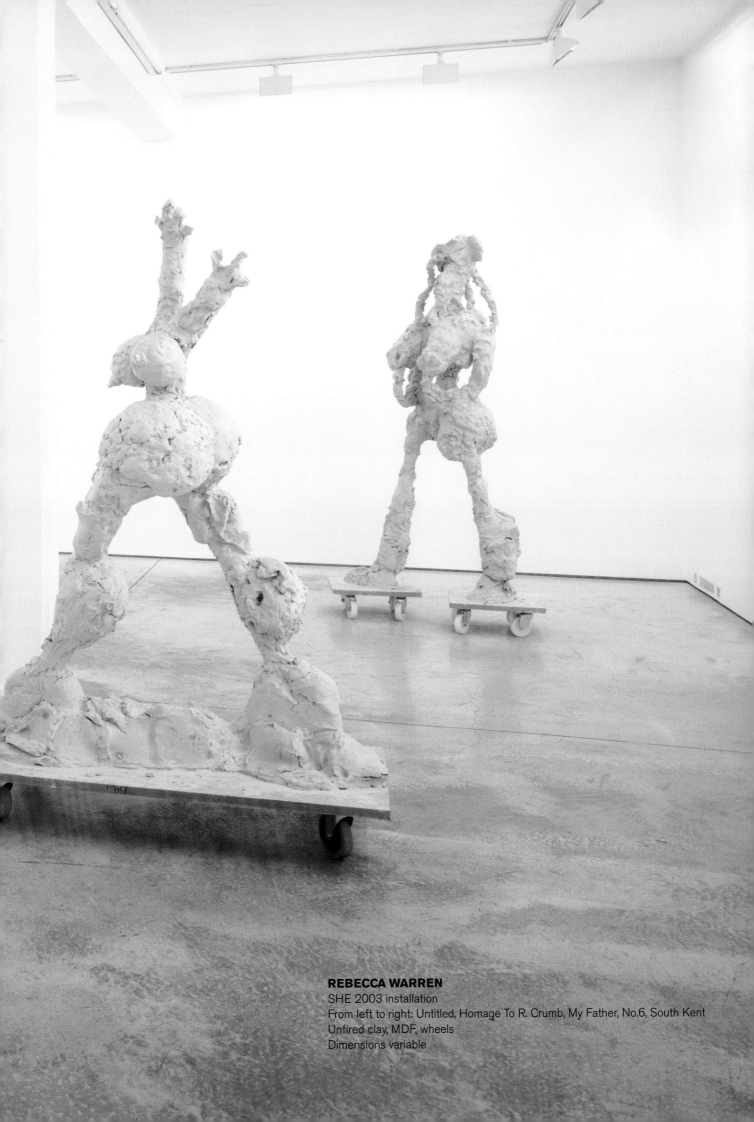

REBECCA WARREN
SHE 2003 installation
From left to right: Untitled, Homage To R. Crumb, My Father, No.6, South Kent
Unfired clay, MDF, wheels
Dimensions variable

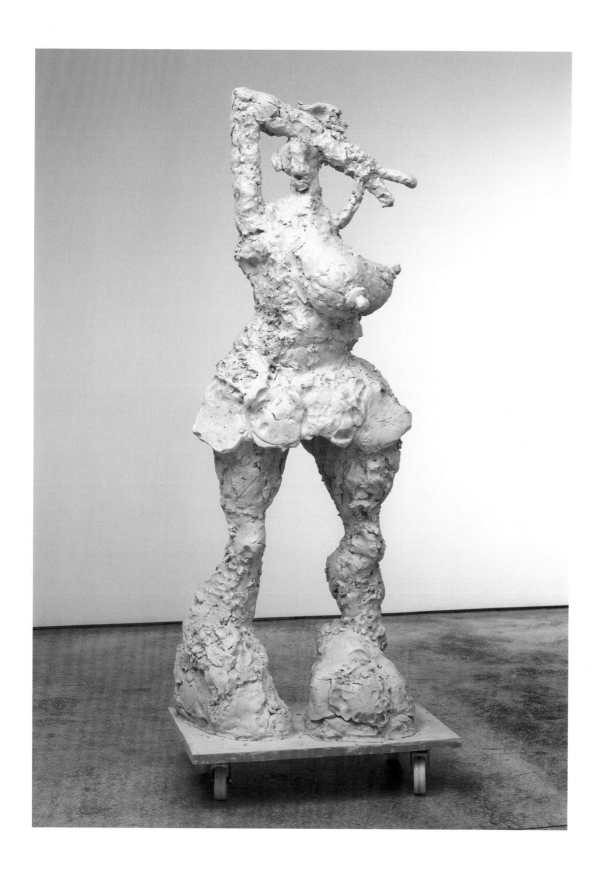

REBECCA WARREN

above:
SHE - Untitled 2003
Unfired clay, MDF and wheels
198 x 46 x 77 cm

right:
SHE - Homage To R. Crumb, My Father 2003
Unfired clay, MDF and wheels
213 x 81.5 x 81.5 cm

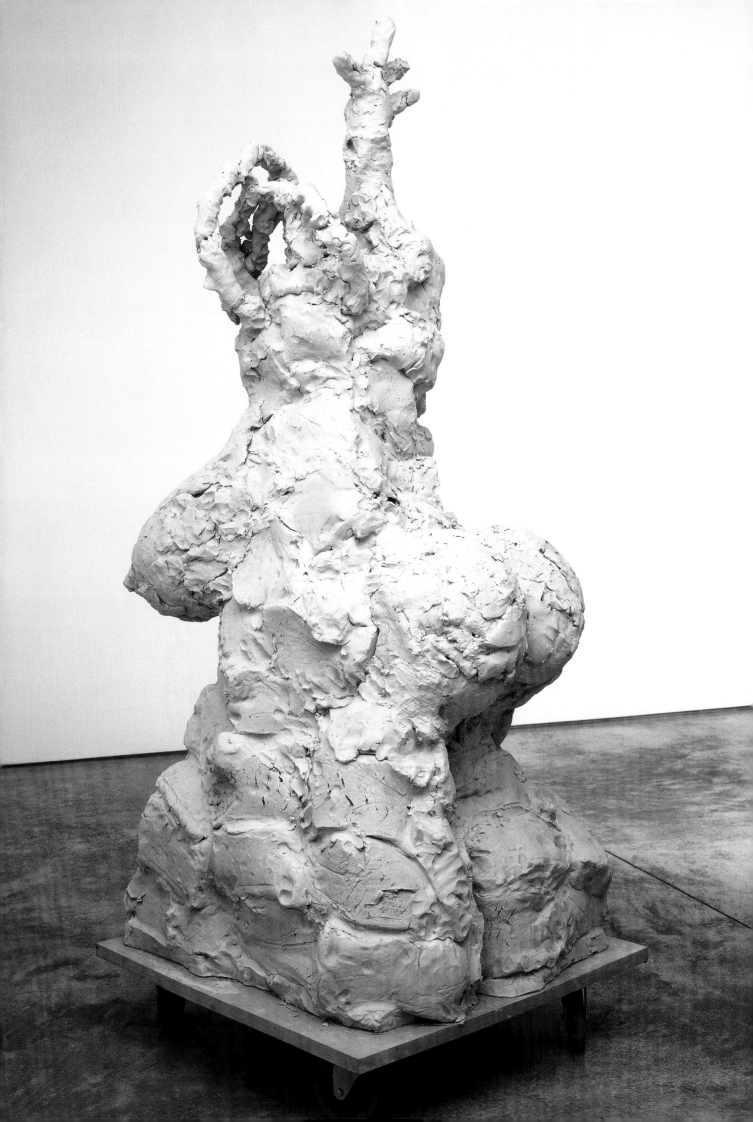

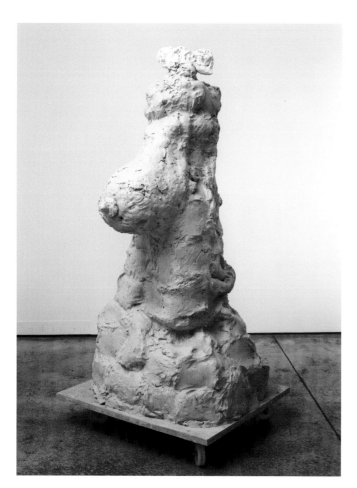 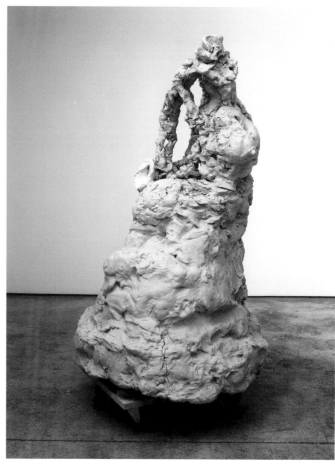

REBECCA WARREN
above:
SHE - Valerie 2003
186 x 76 x 91 cm

above right:
SHE - The Lady With The Little Dog 2003
Unfired clay, MDF, turntable and wheels
178 x 100 x 88 cm

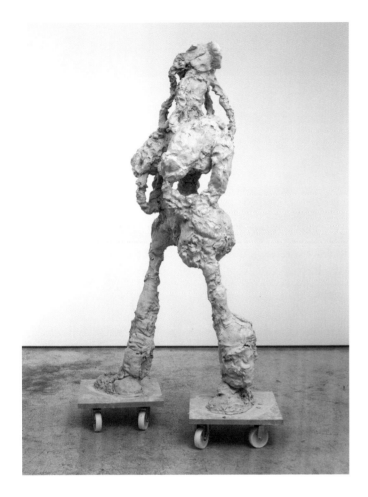

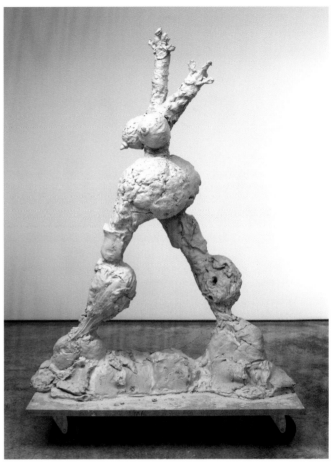

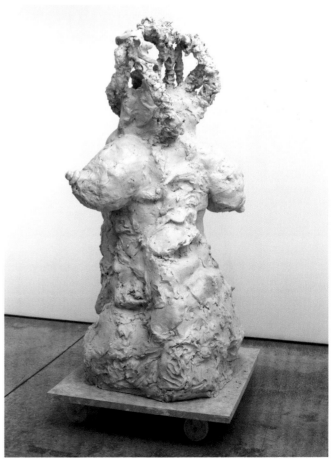

REBECCA WARREN

above:
SHE - South Kent 2003
Unfired clay, MDF and wheels
206 x 127 x 66 cm

above right:
SHE - No.6 2003
Unfired clay, MDF and wheels
186 x 61 x 122 cm

right:
SHE - And Who Would Be My Mother 2003
Unfired clay, MDF and wheels
168 x 76 x 76 cm

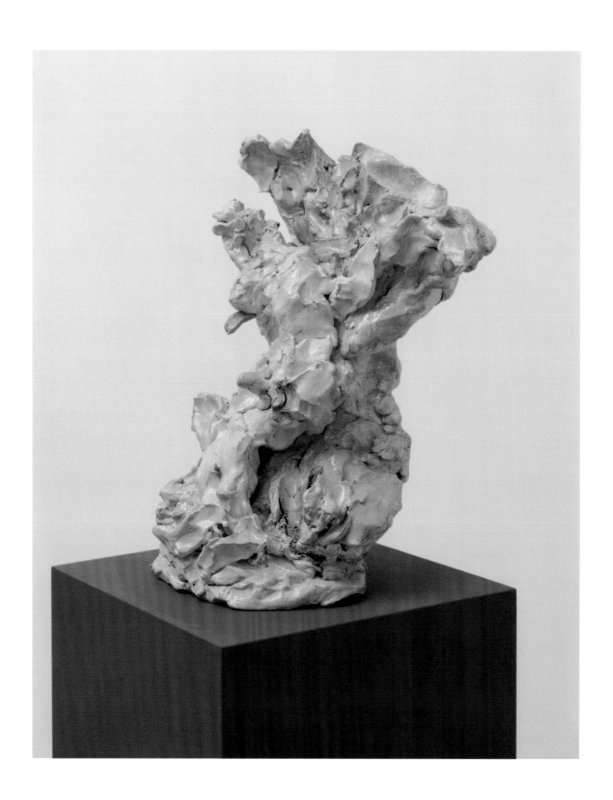

REBECCA WARREN
above:
10-4 2000
Painted unfired clay and plinth
28 x 28 x 40 cm

right:
Croccioni 2000
Unfired clay and plinth
85 x 35 x 84 cm

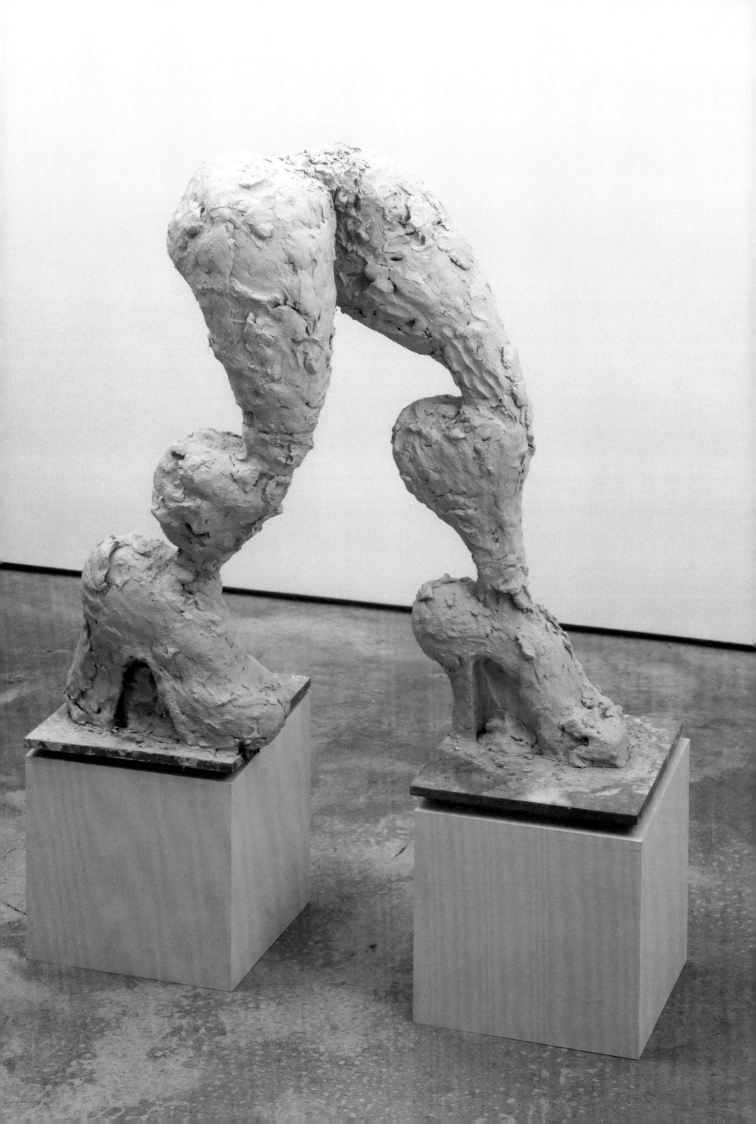

DAVID ALTMEJD

JOHN BALDESSARI

David Altmejd was born in 1974 in Montreal. Since completing his MFA in 2001 at Columbia University, New York, he has had numerous exhibitions internationally. In 2007 he represented Canada at the 52nd Venice Biennale. Altmejd lives and works in New York.

John Baldessari was born in 1931 in California, where he still lives. He has received countless awards, including the Golden Lion for Lifetime Achievement at the 53rd Venice Biennale in 2009. In the same year Tate Modern held a major retrospective of his work, *Pure Beauty*, which travelled to the Metropolitan Museum of Art, New York, Museu d'Art Contemporani de Barcelona and the LA County Museum of Art.

David Altmejd makes large-scale sculptures of anthropomorphic figures cast in a state of metamorphosis. His works explore the boundaries of traditional figuration by embedding his subjects with otherworldly elements and reconceptualizing how to represent the human figure in all its spatial, spiritual and psychological multiplicity.

The New North (2007) is approximately four metres tall; its colossal dimension allows the artist to create microcosmic worlds within it. It is covered in patches of fuzzy horse hair, wires, mirrored rhomboid shapes and quartz crystals; it also has a mysterious staircase with stalagmites that hang from its steps.

Winding their way through the hollow body shape, the stairs are suggestive of mutual ascent and descent, as if inviting an exploration through an ancient cave or ruined architecture. The quasi-taxidermied structure has its own complex logic and systems, like a conceptual city or a building, living and breathing, and self-sufficient.

"When I work, the body is like a universe where I can lose myself. It is a metaphor for the landscape, nature and the mountains", Altmejd has said. *The Healers* (2008), another sculpture over two metres high which is formed of wood, foam, plaster and burlap, shows wildly overlapping figures and figurative fragments – hands, wings, kneeling and kissing figures, rendered as if in the midst of co-dependent, sexually charged physical agony.

Equally reminiscent of baroque compositions representing the descent of the cross as well as of 19th-century public bronze sculptures commemorating battle massacres, Altmejd's elaborate tableau, mixing handmade craft with the illusion of a digital freeze-frame palimpsest, evokes a mood of constant alchemical mutation.

John Baldessari's practice explores ideas around communication. Some of his signature works are conceptual juxtapositions of text and images that demonstrate the enormous associative power of language in the way that art is interacted with and understood. His works have paired statements with found photographs to humorously exploit the game-like way in which narrative can be arbitrarily created by language and visuals.

Beethoven's Trumpet (With Ear) Opus # 133 (2007) is a large-scale work about the paradox of communication's incomplete nature – a sculptural sound piece about a deaf composer. It was one of the artist's first sculptures. "I was asked to do a retrospective show in 2007 in Bonn with all the works I'd done about music. Bonn is the birthplace of Beethoven and I visited his house and he had a whole cabinet of ear trumpets that he used. I was really fascinated with them as sculptural forms, especially one that he had designed himself that I thought was quite beautiful. And then for maybe four or five years I've been doing these works about body parts and I think it started out with noses and ears, so ears were on my mind. And then probably there was one of those three o'clock in the morning moments when you are awake and all of a sudden I thought, 'wait a minute – ear/ear trumpet'."

Baldessari's epiphany and Magritte-like montage of associations creates a piece highlighting how meaning is created through senses beyond the traditionally privileged one, vision – the work is silent until the viewer speaks into the trumpet at which point a section from Beethoven's six last quartets will be heard.

But if this is Beethoven's deaf ear, is the meaning of what is said even connected to the sound that will be heard, and what does the randomness of the fragments indicate? The paradox of communication is once again left up to the viewer to resolve.

DAVID BATCHELOR

David Batchelor was born in Dundee, Scotland in 1955. He has exhibited widely in the UK, Europe, the Americas and Asia. Recent exhibitions include Chromophilia: 1995-2010, Paço Imperial, Rio de Janeiro, Color Chart, Museum of Modern Art, New York and Tate Liverpool. His book, *Chromophobia*, about colour and the fear of colour in the West, is available in eight languages.

David Batchelor makes sculptural installations from objccts found in the streets of London, hollowed, stacked and given a new life as empty but brightly coloured light boxes or as unlit composites.

Consistent throughout his works is the lurking familiarity of the material leftovers of modern life, from factory scrap to disused or broken domestic items, re-purposed into hypnotic, beautifully patterned objects presenting a distillation of colour's presence in our everyday environment.

"When I make works from light boxes (such as *Brick Lane Remix I*, 2003), or old plastic bottles with lights inside, I hope the illumination suspends their objecthood to some degree and makes the viewer see them a little differently – see them as colours before seeing them as objects." The brightest possible palette fills the range of neon-lit columns, modular crates, spherical shapes, and unlit clusters (such as *Parapillar 7*, 2006), the artist's "vehicles for colour."

Batchelor is interested in reconsidering colour theories from a contemporary context, which he explores in *Chromophobia* (2000), his book dedicated to the subject. His dazzlingly saturated objects reconsider the tension between form and the very materiality of colour, perhaps with a wink to earlier forms of light and neon art. "I often use colour to attack form, to break it down a little or begin to dissolve it. But I am not at all interested in 'pure' colour or in colour as a transcendental presence… So if I use colours to begin to dissolve forms, I also use forms to prevent colours becoming entirely detached from their everyday existence."

MATTHEW BRANNON

Matthew Brannon was born in St Maries, Idaho in 1971. Since graduating with an MFA from Columbia University in 1999 he has exhibited widely including shows at PS1 New York, the ICA, London and the Museum of Modern Art, New York. Brannon was included in the 2008 Whitney Biennial. He lives in New York.

Thc titlc of Matthew Brannon's sculpture *Nevertheless* (2009) is an appropriately oblique 'giveaway' from an artist known for the subtlety and humour of his language, objects and prints: "Nevertheless," he points out, "is an adverb comprised of three words: never - the - less. It became my stance against the panic that ensued from the economic collapse. An attempt to answer the question: what can we make when we shouldn't be making anything?"

Brannon's answer to the question is to create shop window-like displays and make-believe theatrical sets. *Nevertheless* was made on the occasion of Brannon's first show in London in 2009, and it was the perfect departure from other work being made at the time around urban malaise. Brannon, based in New York, dedicated the London show to the idea of the transatlantic sea voyage.

"As I was working I was rereading Evelyn Waugh's short autobiographical book *The Ordeal of Gilbert Pinfold*, viewing the cruise episode of his televised *Brideshead Revisited*, and digesting the ship passage in Vladimir Nabokov's *Ada*. There's much to be said about such close quarters. About being in between lands and lost at sea."

What Brannon has made is a sculpture of an installation, like a set for an untold story, in which seduction and frustration are masterfully ever unfolding. The scene's suggestive props (water, curtains, handrails, dirty magazines under the mattress) contrast with an exit sign and rope cordoning off the piece, preventing anyone from entering the installation, and leaving the narrative up to the viewer.

"It's not interactive but you can imagine it being interacted with. I told everyone it was the set of a play. Of a play about a murder on a ship. It's true I did write it, but that's another story. What you're shown here is just the set. I'm allowing you to put the pieces together yourself. To do what you would with it."

PETER BUGGENHOUT

BJÖRN DAHLEM

Peter Buggenhout was born in Belgium in 1963. He has been developing his so-called analogue sculptures, built up with all kinds of debris and abject materials, since 1995. He has had solo shows at Konrad Fischer Galerie Düsseldorf, La Maison Rouge, Paris, Museum Dhondt-Dhaenens, Belgium, and Gallery Maskara, Mumbai.

Björn Dahlem was born in 1974 in Munich. He completed his studies in sculpture at the Düsseldorf Academy of Arts, and has presented his works in numerous solo and group exhibitions both in Germany and internationally, most notably at the Hammer Museum, Los Angeles, the Hamburger Bahnhof, Berlin and the Kunsthalle/KIT Düsseldorf. He lives and works in Berlin.

At first glance, Peter Buggenhout's large fuzzy masses, seemingly covered in thick layers of dust, look like readymade objects, rubble found in the aftermath of a building site, an archaeological dig, or at the scene of a cataclysm – an earthquake, explosion or other force of violent destruction (natural disasters or terrorist attacks?).

Consider his series entitled *The Blind Leading the Blind* (2008) and *Gorgo* (2005), charred rotting hulks bearing traces of what looks like steel building beams jutting from concrete fragments. Or *Eskimo Blues II* (1999), which recalls the sun-bleached remains of a prehistoric creature of unknown dimensions, preserved as if for classification in a museum cabinet. Uncomfortably 'real', but dissected and presented for study by future generations.

In fact, this and Buggenhout's other works are incredibly realistic renderings, carefully made in the artist's studio but suggesting unidentifiable ruins. In confusing viewers, Buggenhout's sculpture raises questions around the subjects artists choose as their models and the strong influence of projection on the way art is perceived.

The objects here intimate the theme of the 'ruin' that surfaces through art history, but in its more direct and subversive mood. These works convey an organic, blurred relationship between representation and abstraction that breaks down perceived assumptions about the way objects are classified and understood.

But what appears to be there upon first looking remains a lingering presence that the viewer cannot entirely ignore. "I consider my works as analogies. All these analogies bear the consoling thought that they were created by human hands, that they are viable and bring viability that is hardly, if at all, bearable into a chilled, inhumanly large world. These analogies do not operate within the standard artistic norm because they do not intend to pass judgment, preach or pass on emotions. They simply are, there is more than meets the eye, after all."

Björn Dahlem makes room-sized sculptures that represent abstract concepts of space and matter. His creations are based not on stability, but on fragility which he sees as the defining condition of human knowledge. His low-tech wood and light assemblages allude to cosmic theories and philosophy, re-imagining the ways the universe is understood in startlingly simplified terms.

The material properties of wood and its ubiquitous availability make it a constant in Dahlem's sculptural repertoire. "Wood allows me very immediate access to my ideas, because what I'm trying to do is to stay as close to the idea and the immaterial image of the imagination." In some sculptures, wood is paired with light, a symbol of the immaterial and of enlightenment.

The Milky Way (2007) is a sprawling web of wood and neon tubes illustrating its title subject, but without pretending to be to scale, useful or even correct. The work hinges on the immediacy of easily recognised forms and symbols (lumber, lights, a jar of milk), which Dahlem has transformed into what he calls a "thought model" or "mental habitat": "When I work on the sculptures I always try to be like a child… [thinking, for example,] today I'm going to build the cosmos with orbits of planets."

Schwarzes Loch (M-Sphären) (Black Hole (M-Spheres), 2007) is part of a series of hovering constructions composed of wooden polyhedron shapes to which incandescent and fluorescent lights have been attached. At its core is a smaller, black polyhedron, a disarming version of the real thing, a black hole – popular scientific knowledge turned into a mysterious, self-defined new.

Cathedral (2008), a towering wooden assemblage fixed around a teetering pile of jars of glacier cherries, is a made-up model of a parallel reality, rife with an absurd, incomprehensible instability.

BERLINDE DE BRUYCKERE

FOLKERT DE JONG

Berlinde De Bruyckere was born in 1964 in Ghent, Belgium, where she still lives. Her exhibition 'Mysterium Leib. Berlinde De Bruyckere im Dialog mit Cranach und Pasolini' will tour in 2011 to the Musée des Beaux-Arts de Lyon, the Kunstmuseum Bern (Switzerland) and the Kunstmuseum Moritzburg (Germany), finishing in 2012 at the Kunsthalle Vienna.

Folkert de Jong was born in 1972 in Egmond Aan Zee, the Netherlands. Since completing his MFA in 1999 at the Rijksakademie van beeldende kunsten in Amsterdam, he has had numerous exhibitions internationally. In 2009 he had his first retrospective solo show at the Groninger Museum in the Netherlands. Folkert de Jong lives and works in Amsterdam.

An unsettling, reconfigured concept of the body, helpless yet contorted, takes centre stage in Berlinde De Bruyckere's faceless sculptures. Abject deformation is turned into beauty as if the artist is trying to wrestle a shape from abstract form. That each body, whether human or equine, stands on a plinth or inside a cabinet, as if posing for the viewer, emphasises their monumentalised objecthood and the tension between what these objects represent and what they actually are.

De Bruyckere began making work around ideas of the human figure in the early 1990s, first through its absence, stacking and draping woollen blankets on furniture, symbolising shelter and vulnerability. Then she added bodies made of wax, almost completely covered in wool; imperfect, sexless and headless.

Their lack of eyes and sex emphasised the importance of seeing each body as a whole. A few years later she made the horse her subject, covering pseudo-anatomical works in familiar materials that inspire both a sense of nightmarish displacement and visual allure, of animal suffering and material abstraction.

The horse pieces are eyeless (*K36 (The Black Horse)*, 2003) and sometimes headless too (*K21*, 2006). The glossiness of their skin underscores all of the things that are covered and hidden, a sensual, almost tender casing for these uncomfortable shapes.

Marthe (2008) shows a body in duality, disgusting but still half-human, a hand found in its twig-like limbs reminiscent of Ovidian-style transformation; it too, despite its lifelike physicality, is sexless, headless, inert, a re-imagined object. "It is not because you never see a head that it looks like it has been cut off. It is, rather, that I no longer think the presence of a head is necessary. The figure as a whole is a mental state. The presence or absence of a head is irrelevant."

Folkert de Jong's figurative installations combine a touch of ironic Old Master tableaux vivant-style composition with a strong dose of the macabre. His polyurethane foam mannequins have an arresting life-like quality, which makes their dirty and broken down facture all the more affecting.

Frozen in permanent gestures like ventriloquist's dummies (*The Peckhamian Mimic*, 2007), sometimes quasi-drunkenly gurning or grinning, as in *Asalto de la Diligencia* (2008) or expressionlessly looking on, these posturing figures have an eerie charge, like carnivalesque puppet grim reapers rising from the detritus of post-industrial culture, poignantly made out of a material that will not last.

Thematically, de Jong's carefully decayed constructions often deal with unfair deals, profiteering, and the ghosts of colonialism and imperialism. The figures in *The Dance* (2008) all happen to be made from a single mould, based on a composite of a 16th-17th century trader character amalgamated from historical figures such as Pedro de Alvarado, Peter de Minuit and Hernan Cortes, as well as Rembrandt's *Nightwatch*.

The installation recalls the monument in New York's Battery Park celebrating the Dutch purchase of Manhattan for some beads and mirrors; here, as the artist explains, "the clones are trading with themselves, their own kind, ripping off each other and dancing towards their destiny: self-destruction." The characters' grand, nightmarish song and dance has a deathly tone, with its symbolic black coating, like dripping tar.

There is something inherently perverse about making such carefully crafted figures out of a material so trashy, fragile and ephemeral. The desolate figures in *The Shooting Lesson* (2007) recreate characters taken from Picasso's *Les Saltimbanques*, melancholy harlequins reminiscent of the cycle of life and of human powerlessness. "We humans have to face the fact that we are part of a natural process, no matter who or where you are on planet earth. It is embedded in our system, but there is hope! Morality, intelligence and compassion can save us."

ROGER HIORNS

MARTIN HONERT

Roger Hiorns was born in 1975 in Birmingham, UK, and completed his BA in the 1990s at Goldsmiths University, London. Hiorns was nominated for the Turner Prize in 2009, and in the last 12 months his work has been shown at Tate Britain, The Chicago Art Institute, the Walker Art Center, Minneapolis and De Hallen in Haarlem, the Netherlands. He lives in London.

Martin Honert was born in 1953 in Bottrop, Germany and studied at the Academy of Fine Arts Düsseldorf (1981-1988). Honert was first exhibited at the Saatchi Gallery when it was located at Boundary Road in 1997 as part of the 'Young German Artists 2' show. He lives and works in Düsseldorf.

Roger Hiorns' sculptural practice meditates on the act of artistic creation, observing what happens when the process is handed over to reactive, 'living' material and its metamorphoses. *Copper Sulphate Chartres and Copper Sulphate Notre-Dame* and *Leaning Chartres With Cobalt and Copper Crystals*, all from his Goldsmiths degree show in 1996, as well as his more recent large-scale installation *Seizure*, highlight his apparently no-hands method: a chemical solution is allowed to take over an existing object or space, and a found form and its meaning is transformed, as if by self-design. The way crystal formations shape themselves on these cardboard models creates a living sculpture, reminiscent of creeping ivy on statues, of historical ruin. It also undoubtedly recalls the slow-forming processes of geology, suggesting a latent constant potential for material transformation.

Many of Hiorns' three-dimensional projects yield to the autonomous generative properties of his chosen substance (crystallising fluid, detergent foam, fire) to 'isolate' objects, to make us conscious of their origins and their contexts. His diptych *Untitled* (2010) combines ordinary and esoteric materials – polyurethane, polyester and brain matter – to explore transparency as a sculptural property.

"We're surrounded by codified practices consistently imposed on us by dominant objects. We're under a narrow coercion from the objects that we design for ourselves. Of course, this question is strikingly obvious: Are we a balanced society? Can we retool our objects, perhaps? What would that involve, and is it possible to transgress the continuous production of next-generation objects, to insert transgressive stimulus, the cross of semen and the light bulb, for example? To retool, simply to ask: Do we live in a society where we make objects towards the darker side of our psyche? Is it useful to continue this procedure even further, with more necessity and speed?"

Hiorns' inconsistent sculptural practice rebels against the idea of unquestioned limitation in art and, by extension, calls for a liberation of the assumed status quo on a broader sphere.

Martin Honert's meticulously rendered sculpture *Riesen (Giants)* (2007) is inspired by memories of his childhood. "Childhood is a theme for me because I think it's important to discover what's way past but still in the memory as an image."

His large-scale human figures manage to capture a vivid immediacy and sense of wonder achieved by recreating the world from a child's point of view. Instead of looking back from an adult's nostalgic perspective, the artist bases his works on family photographs and illustrations from schoolbooks, as well as his own childhood drawings, using scale and illusion to "save an image before it dies within me".

A feeling of being afraid in a huge and empty exhibition space originally inspired Honert to make his oversized figures. The sculpture is composed of two bearded men, dressed in ordinary, contemporary clothing. The fact that they are each close to three metres high is not entirely fantastical or arbitrary; Honert took this specific measurement from the tallest man of the 20th century, an acromegalic American named Robert Wadlow.

The figures wear backpacks, trekking boots and hoodies; their clothes bear marks of wear and dirt, and one of them holds a walking staff. But despite their unremarkable appearance, and their conventional realism, something about their purpose remains unexplained to the viewer.

Like Cyclops-sized giants that have strayed into the gallery, they could be updated mythical wandering characters from a fairytale set in the wilderness, or social outsiders, fearsomely fending for their own survival.

THOMAS HOUSEAGO

Thomas Houseago was born in 1972 in Leeds, UK. He has had solo shows at Xavier Hufkens, Brussels, the Stedelijk Museum, Amsterdam and Modern Art Oxford. Recent group shows include 'The Artist's Museum', MOCA, Los Angeles, the 2010 Whitney Biennial, New York, and 'The Library of Babel / In and Out of Place', Zabludowicz Collection, London. Houseago lives in Los Angeles.

Thomas Houseago's sculptures are full of contemporary paradox and contradiction: heavy and static yet animated; fully formed yet seemingly unfinished; unabashedly crude yet technically experimental; spiritually charged yet also ironic in their hybridity; echoing art history yet blank, like a tabula rasa; monstrous yet beautiful; and eerily fragile, inspiring fear and fascination in equal measure.

His sculptures re-situate the figure as a performance in flux and as something not to be taken for granted. They occupy a space between abstraction and representation, with one foot in the past and the other in the future. From prehistoric cave and folk art, ancient and classical sculpture, to Michelangelo, cubism, pop culture, music and the work of his contemporaries, such as Matthew Monahan, Houseago's figures reveal a syncretic absorbance of a multitude of styles and influences which he has transformed into a sculptural language that is entirely his own.

Working with basic materials such as clay, plaster and jute, he mixes media with child-like enthusiasm, often drawing directly onto panels and embedding them into the finished pieces, which are both three-dimensional and flat.

Untitled (2000) is a headless, legged torso equal parts superhero and archaeological find. *Joanne* (2005), a simplified, proto-figurative form, is dominated by a sinister face peeking out from a plaster cocoon, its hollow eyes and mouth recalling ancient ritual masks. *Caryatide with Squatting Man* (2000) nods to the archaic sculpture and modernist art of Brancusi. The forward-leaning *Folded Man* (1997) and *Figure 1* and *Figure 2* (2008), cutout cartoons fleshed out by the artist's use of drawing, are perfectly balanced and powerful despite the precariousness of their exaggerated poses.

"As a sculptor, bottom line, I am trying to put thought and energy into an inert material and give it truth and form, and I believe there is nothing more profound than achieving that."

JOANNA MALINOWSKA

Joanna Malinowksa was born in Gdynia, Poland in 1972. She has an MFA from Yale University, and has shown her work at the Kunstmuseum Bern, Zamek Ujazdowski Contemporary Art Center, Warsaw, The Sculpture Center, New York, the 1st Moscow Biennale, and the Prague International Biennale. In 2009 she received a John Simon Guggenheim Memorial Fellowship in Visual Arts. She lives in Brooklyn, New York.

It's impossible to ignore the presence of Joanna Malinowska's *Boli* (2009), an oversized, confounding sculptural 'elephant in the room' holding court in the centre of the gallery. The rough animal shape is similar to a traditional object of significance to the Bamana culture in West Mali of the same name, also vaguely bovine but usually much smaller.

Traditional *bolis* represent the Bamanan cosmos and are held in a special location by village elders. They can be made out of earth, blood, cattle dung, kola nuts and other material related to spiritual ritual. Malinowska's hypertrophied version of the talisman is made out of plaster, clay, hay, wood, scraps from Spinoza's *Ethics*, a litre of water from the Bering Strait, and a sweater belonging to Evo Morales, the Bolivian President. Just like with traditional *bolis*, its materials could be interpreted, but the whole is more than the sum of its parts.

Inspiration for Malinowska's sculpture, performance and video-based projects comes from her fascination with anthropology, and her works often playfully suggest her own take on anthropological field work and interpretation. "Before choosing art, I had considered becoming a cultural anthropologist, but eventually decided that what made me interested in anthropology was not so much the research that aspires to scientific objectivity, but rather the sense of relativity of a cosmic order of one's own culture in comparison to other possible systems."

Malinowska's *Boli* re-creates the Bamanan original with a new set of materials, and embodies the artist's interest in re-imagining the way objects are charged with meaning. "If asked to find a common denominator in my recent works," the young Polish, New York-based artist says, "I would say it is an interest in methodically testing and engaging the invisible, hidden aspects or powers of an object, revitalizing its metaphysical potential, and simply giving it the benefit of the doubt."

KRIS MARTIN

Kris Martin was born in Kortrijk, Belgium in 1972. He has had many solo shows, most recently at the Wattis Institute for Contemporary Arts, San Francisco, White Cube, London and the Aspen Art Museum, Colorado. He will take part in the Istanbul Biennial in September 2011, and in 2012 he will have a major exhibition at the Kunstmuseum Bonn. He lives in Ghent, Belgium.

Standing on top of each of the large megalith-like boulders that comprise *Summit* (2009), Kris Martin's eight-part found rock installation, is a small marker. When, and if, spotted, these identifiers change the viewer's perspective and turn the room's vaguely prehistoric ambience into less numinous territory.

A small paper cross crowning each peak indicates that they have all been conquered, and by using a charged symbol whose real-life application connotes a range of meanings – of man conquering the limits of awe-inspiring nature, of a civilisation conquering another civilisation, of death conquering all – Martin sets in motion a stark thinking process.

Within the artist's visual pun there's also perhaps a metaphor for the importance of process in art-making itself. "The top is nice when you haven't reached it," Martin has said. "But once you get [there], the potential is gone. Dreams are what keep people going."

Martin's conceptual installation, repeating the same conceit eight times over, is a comment both on the futility of human ambition – what is left once seemingly unreachable summits have been conquered? – and also on the oppressive and absurd spread of consensual, hegemonic belief.

Reminiscent in their exotic roughness of the blue, impossibly steep and faraway mountains that steal the fantastic landscapes of Joachim Patinir and his 16th-century contemporaries, these lifeless stand-ins humorously exaggerate the heights to which human foolishness and its quixotic desire can rise. "For me, they're all very dangerous, mountains… They're filled with a dangerous power, especially for puny little human beings, like we are."

MATTHEW MONAHAN

Matthew Monahan was born in California in 1972 and attended the Cooper Union School of Art, New York, and Gerit Rietveld Academy, Amsterdam. Recent solo exhibitions include the Contemporary Arts Center, Cincinnati, Anton Kern Gallery in New York, Stuart Shave/ Modern Art in London and the Los Angeles Museum of Contemporary Art. He lives and works in Los Angeles.

Like the unearthed contents of a time capsule found by a future generation, Matthew Monahan's sculptural plinth assemblages are chock full of mystifying information. Despite the flimsiness of their materials – Styrofoam, drywall, clay and paper –, they are charged with an altar-like, quasi-shamanistic power.

Monahan shows the human figure in a state of corruption and digitalised fragmentation, like a post-technological ruin, warped and distorted. His work displays a confounding range of influences, from prehistoric art to 17th-century cabinets of curiosity, from 20th-century art to postmodern cyborgs and electronic media.

Blindness Is Believing (2005) and *Midnight Mission* (2009) are totemic representations of a human figure once hallowed, whose would-be grandiosity is conveyed by their metallic (though just painted-on) sheen.

Blood For Oil (2005) displays various apparently unrelated elements, hinting at a possible link, perhaps a ceremonial purpose; a similar conceit pervades *Riker's Island* (2005), in which the artist creates an assemblage out of preserved relics dominated by manipulated black and white human faces placed next to perplexing fragments of objects.

Guild Of Mad Builders (1994) riffs on the idea of the museum display. It contains elements that reference the work of early 20th-century Constructivist sculptors but re-contextualised into a fictional set-up with its own internal logic.

Many of Monahan's compositions explore the darker side of figuration. *Sweet Grunt* (2005) shows the folk character of the Green Man as a frowning, evil-spirited golem, stomping all over a guileless classical countenance. *The Benjamins* and *Tarted Up For The Lions* (both 2005) use a columnar display to focus on the body as something irreparably broken and corroded.

Lesser Known Son (1994) is more singular in form, composed of a pedestal displaying a chimeric face bearing a mysterious inert tranquillity. *The Family Tree* (2005) is a portrait rolled into a cone-shaped object – of idolatry, or a standing pyre to be burned and rebuilt?

ANSELM REYLE

Anselm Reyle was born in Tübingen, Germany in 1970. He has had solo shows at Kunsthalle Zurich, the Modern Institute, Glasgow, Galerie Giti Nourbakhsch, Berlin and Gavin Brown's Enterprise, New York. He has participated in numerous group exhibitions including Migros Museum, Zurich and the Galleria Civica di Arte Contemporanea, Trento. He lives in Berlin.

Anselm Reyle's practice appropriates art styles from the 20th century in an attempt to redefine what Modernism was and how its influence has been inherited by contemporary art. His appropriation of historical styles updates and questions the authenticity of such paradigms, while ambiguously perpetuating their canonisation. "I don't just want to take something up and present it as an available form. I deal with it more like objets trouvés that I come across because they fascinate me and then I intensify this fascination, and so want to show it. And I'm partly interested in styles as well because they are so well-worn."

His most well-known works are the so-called 'African Sculptures', such as *Untitled* (2005), a piece whose form quotes from kitschy and cheap tourist market handicrafts as well as from modernist Africanism and the work of prominent abstract sculptors of the 20th century (Arp, Brancusi, Moore, Hepworth). Reyle fuses these parts into a seamless, retro-futuristic whole, coating traditional hand-shaped materials with the gaudy, industrial-edge of chrome varnish made to look like purple plastic foil.

The outcome is an object at once familiar yet dissembling, as authentic and real as the original sources but purposefully empty. Reyle's light installation, *Untitled* (2006), composed of 119 found neon tubes, cites and subverts more tropes and materials of modernist formalism. Seemingly chaotic but carefully composed, it suggests a madness held in check but uncomfortably on the verge of being out of control.

STERLING RUBY

Sterling Ruby was born in Bitburg, Germany in 1972. His work is in the collections of Tate Modern, London, Hammer Museum, Los Angeles, MOCA, Los Angeles, LACMA, Los Angeles, MoMA, New York, and The Solomon R. Guggenheim Museum, New York. In 2011, he will have solo exhibitions at Xavier Hufkens Gallery in Brussels, and The Pace Gallery in Beijing. He lives in Los Angeles.

Sterling Ruby works prolifically in a wide range of mediums, from glazed biomorphic ceramics and poured urethane sculptures, to large-scale spray-painted canvases, nail polish drawings, collages and videos.

Through his varied practice he conducts an assault on materials and social structures, referencing subjects that include marginalised societies, maximum-security prisons, modernist architecture, artefacts and antiquities, graffiti, bodybuilders, the mechanisms of warfare, cults and urban gangs.

Monument Stalagmite/Headbanger (2008), *Recondite* (2007), *Kiss Trap Kismet* (2008) and the suggestively bloodied *Headless Dick/Deth Till* (2008) are large enough to raise questions around sculpture's assumed relationship to the human scale. In contrast to the pure conceptual forms of minimalism, Ruby's messy aesthetic, with its spray marks, dripping paint and worn down edges presents iconoclastic graffitied objects as visceral, organic systems that possess a manmade quality and an allure despite their overt ugliness.

His works are unique hybrids of sources, media, glosses on tradition and autobiographical notation. "*Recondite* is modelled after a small desktop meditation fountain given to me by my mother. I had just come back from a trip to Germany [where Ruby was born], and I realized this small fountain reminded me of some of the fascist architecture I had just seen. The monument plays a big role in much of my work because it is defined as a structure built for the sole purpose of remembering something that has been lost. I came up with *Recondite* as a title, as it refers to esoteric or specialized knowledge. I was addressing the way artists of my generation felt trapped by a kind of post-modern burden of ideas, theories, and histories. It seemed impossible to make a sincere gesture anymore. This was my monument to all of that."

DIRK SKREBER

DAVID THORPE

Dirk Skreber was born in Lübeck, Germany in 1961. In 2000 he received the Preis der Freunde der Nationalgalerie für junge Kunst from the Hamburger Bahn-hof, Berlin, one of Germany's most prestigious art awards. He has had recent shows at Blum & Poe, Los Angeles, Friedrich Petzel, New York, Frans Halsmuseum, the Netherlands and Museum Dhondt-Dhaenens, Belgium. Skreber lives in New York.

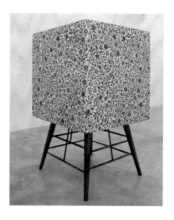

David Thorpe was born in 1972 in the UK and completed his MA in Fine Art at Goldsmiths University, London. His most recent solo exhibition was at the Kunstverein Hannover in 2010. He has also had solo shows at the Kunsthaus Glarus, Switzerland, Tate Britain and Camden Arts Centre, London, and Museum Kurhaus Kleve, Germany. Thorpe lives in Berlin.

In Dirk Skreber's sculptures, such as *Untitled (Crash 1)* (2009), the crashed car is recycled from a subject of horror into a kind of metaphysical art. Skreber's spectacular fabrications are impossibly twisted distortions of the familiar object, crushed and curiously wrapped around supporting columns.

It is as if they have been caught, mid-flight, through an invisible centripetal speedway, and are being held in a state of unreal suspension and impersonal destruction, as if in an anxious automotive purgatory.

The artist's choice of subject riffs on his memory of the inhuman but fascinating spatial energy where he first encountered this imagery. "When I was young… the industrial area I lived in [Northern Germany] inspired a sculptural and mechanical outlook more than a painterly one. If I were to write a novel about this area I would call it 'The Region'… At an early age I subconsciously perceived this industrial environment as sculptural". Exploring the formal potential of the car, and bending its natural anatomy away from any predetermined functional sense, became a central preoccupation for the artist's imagination.

Skreber obsessively painted cars wrapped around poles before moving onto the real thing. "Although I was satisfied with the paintings, I wanted to go closer to the material reality of my subject. I started thinking about a simulated crash, which was staged according to my sculptural vision… While making these works my concern was not at all about accidents but rather to use a massive and completely real transfer of energy as an opening door to a perspective on the flow of physical laws and metaphysical energies, loading and unloading, transforming and retransforming like batteries or spiritual bodies."

David Thorpe's work is concerned with the relationship between objects and their makers, with a particular interest in the role of craft and labour in handmade design and art. "I'm playing with certain associations," he has said, "slightly New Age, slightly Space Age, slightly threatening… I'm absolutely in love with people who build up their own systems of belief." This idea is reflected in works that variously reference modernist principles of object-making, utopian social architecture, Japanese woodblock prints, and Victorian paper-cutting.

In the past Thorpe has made elaborate collaged paintings, but his more recent work explores the actualisation of pattern through unusual three-dimensional renderings that highlight the tension between exquisite decorativeness and the aura of DIY home-craft manuals.

The works shown here all make reference to an interconnectedness between ideology and lifestyle. *I Am Golden* (2002) is a miniature temple-like structure that also doubles as a plant stand. *Endeavours* and *Private Lives* (both 2010) allude to the aesthetics and theories of the Arts and Crafts Movement of the late 19th century and the democratising art ideals of William Morris and John Ruskin. Thorpe's large pattern-covered objects have been executed with the collaborative assistance of skilled artisans trained in recreating labour-intensive medieval recipes for making paint and ceramic moulds.

The mesmerising repeated motifs of *Endeavours* are inspired by William Morris' elaborate title page for John Ruskin's famous essay 'Nature of Gothic', which defines the artist as 'a Naturalist' who seeks true beauty by illustrating nature and the human being 'in its wholeness'.

Labour in and of itself stands as the central, distilled idea behind Thorpe's object, whose functionality is deliberately unclear. *Private Lives*, a plaster form resting on wooden legs, is similarly adorned with stylised leaves and vines made of carefully cut leather. Emanating from it is a light that imbues the sculpture with an almost devotional symbolic charge of self-sufficiency.

OSCAR TUAZON

Oscar Tuazon was born in 1975 in Seattle, USA. After studying art and architecture in New York, he moved to Paris in 2007 and co-founded an artist-run collective, castillo/corrales. He has had solo shows at the ICA, London, Kunsthalle Bern, Künstlerhaus Stuttgart, David Roberts Foundation, London, and Palais de Tokyo, Paris. He lives and works in Paris.

The private becomes open terrain in Oscar Tuazon's *Bed* (2007-2010), a wooden installation showcasing the artist's all-encompassing practice, which makes few distinctions between sculpture, architecture and DIY self-sufficiency. *Bed* was originally created to fit into the artist's apartment and sleep on.

"Just before my daughter was born I decided I needed to build some new furniture. I had no job, no money, not much anyway but enough for twelve sheets of OSB, screws and paint. What I had in mind was a floor that lifted up so you could sleep in it. I put the bed down in the center of the room and built around it, building out around the walls, the doors — finally I had to cut through the doors so they'd open into the space. I put down a coat of enamel then the baby arrived. Then we had to live with it. It was never comfortable, it was the kind of furniture that tells you how to sit and then punishes you anyway. There was a fire last year in the apartment downstairs and we had to move on. The bed survived, and kind of became its own thing."

In this work, Tuazon reconceives the most intimate domestic space, emblematically turning it into a spartan minimalism. The artist, who trained at the Acconci Studio and has followed Vito in making his own anarchic interventions in galleries, uses common industrial materials and building techniques to customise this everyday object, even if at the expense of comfort. His structure, as perversely uncozy as it is, comments on the unquestioned acceptance of mass design and encourages us to think about the boundaries between life and art.

It's perhaps no surprise to learn that Tuazon comes from Seattle, home of the Utilikilt — a specialist workman's kilt with plenty of pockets.

REBECCA WARREN

Rebecca Warren was born in 1965 in London. She was nominated for the Turner Prize in 2006 and the Vincent Award in 2008. She has recently had solo shows at the Serpentine Gallery in London and The Art Institute of Chicago. In 2011 she was included in 'Modern British Sculpture' at the Royal Academy of Arts, London. She lives and works in London.

Ranging from the amorphous to more clearly recognisable forms, Rebecca Warren's sculptures create a bold new figure for the female nude. Her subject is one of the most traditional in art history, but she subverts the inherited cliches associated with the genre, redefining what sculpture should be or should look like. With their earthy, unfired and unfinished look, they unveil a tension between thought and process, while creating a unique, new sculptural mode.

Warren, who belongs to the same generation as the YBA artists from the 1990s, has developed an aesthetic entirely her own. Clay, a very flexible medium, allows her to explore unconscious free association. "The beauty of working with a material like clay is that it gives you that freedom to change things… I like to keep the quality that they're breeding quite quickly and they're made quite quickly, that there's a sense of them perhaps not being complete, to keep them alive and dynamic and fresh".

In her work, Warren wryly addresses her fascination with artists who have overtly fetishised the female form: photographer Helmut Newton, cartoonist Robert Crumb, and abstract expressionist Willem de Kooning. Her earth mothers quote from their imagery, and from that of modernist sculpture, highlighting a shared interest in sexualising women's shape by discarding heads or any personal attributes, and filtering symbols of objectification — aggressively cartoonised buttocks, nipples and postures.

Feminist appropriation is layered with a variety of other influences. The figures in *She* (2003) were originally inspired by Picasso's *Les Demoiselles d'Avignon*. The stepping *Croccioni* (2000) alludes to Crumb, to a Boccioni sculpture and to 1970s rock culture (as could the tongue sticking out of *10-4*, from 2000), creating a layered meaning that's specific yet open-ended. The amalgamation of references and ideas in her work allows her to re-engage with traditional art while remaking it all her own.

The Saatchi Gallery gratefully acknowledges the following who have contributed photographs of the artworks:
Cary Whittier, Sam Drake, Justin Piperger, Stephen White, Peter Cox, Reni Hansen, Blaise Adilon, James Cohan Gallery,
Aatjan Renders and OFFICE For Contemporary Art, Amsterdam, Karl Wolfgang, Sterling Ruby Studio, Lamay Photo,
Museum Kurhaus Kleve (Annegret Gossens), Mirjam Devriendt, Tom Baker

Artist portraits:
David Altmejd courtesy Jessica Eckert, John Baldessari © Sidney B. Felsen, David Batchelor courtesy Guinam Moon,
Matthew Brannon courtesy Wonge Bergmann, Björn Dahlem courtesy Fabian Schubert, Berlin, Berlinde De Bruyckere
© Mirjam Devriendt, Folkert de Jong courtesy Aatjan Renders, Roger Hiorns courtesy Tate, London, Thomas Houseago
courtesy Fredrik Nilsen, Anselm Reyle courtesy Hedi Slimane, Sterling Ruby courtesy Hedi Slimane and Almine Rech
Gallery, Paris, Dirk Skreber courtesy Albrecht Fuchs, Cologne, Rebecca Warren courtesy Jake Walters and
Maureen Paley, London

The Saatchi Gallery would also like to thank:
Alison Jacques Gallery, Anton Kern Gallery, CANADA New York, Casey Kaplan Gallery, Contemporary Fine Arts Berlin,
Corvi Mora Gallery, David Kordansky Gallery, Friedrich Petzel Gallery, Gagosian Gallery, Galerie Fons Welters, Galerie Giti
Nourbakhsch, Galleria Continua, Gallery Maskara, Herald Street Gallery, Irena Hochman Fine Art, Johnen Galerie,
Jonathan Viner, Maureen Paley Gallery, Modern Art, OFFICE For Contemporary Art Amsterdam, Sies + Höke Galerie,
Sprüth Magers Berlin London, Sterling Ruby Studio, The Approach, Wilkinson Gallery, Andrea Rosen Gallery

Published by the Saatchi Gallery in 2011
© Saatchi Gallery 2011
ISBN 978-0-9538587-9-8

Introduction and texts © Lupe Núñez-Fernández 2011

Front cover: Joanne, 2005 by Thomas Houseago
Back cover: Endeavours, 2010 by David Thorpe

Lupe Núñez-Fernández is a writer and translator based in London and Madrid. She was formerly deputy editor of
ArtReview, an editor at Phaidon Books and on the editorial staff at Modern Painters and LUX.

Designed by Georgina Marling of the Saatchi Gallery and Peter Gladwin of ArtQuarters Press
Printed by ArtQuarters Press, London